IMAGES
of Rail

RAILROAD DEPOTS
OF NORTHERN INDIANA

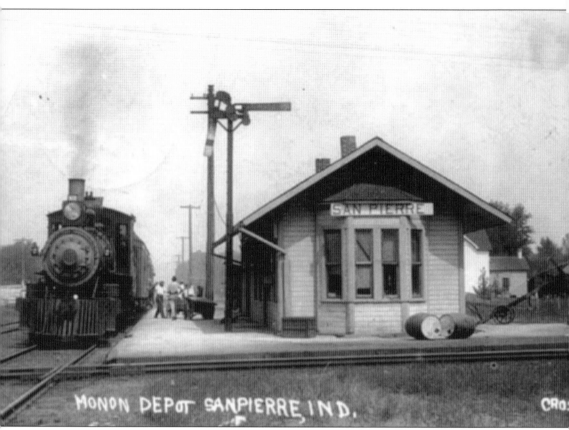

MONON DEPOT SANPIERRE IND.

CRO:

SAN PIERRE DEPOT POSTCARD. This image shows a steam locomotive stopped at the Monon Depot at San Pierre. San Pierre was one of the Monon Railroad's earlier stops, being established in 1853. (Courtesy of Edna M. Stonecipher.)

On the cover: ARRIVING AT THE DEPOT. Taken around 1920, this image shows what would have been a common scene on a summer weekend at the Nickel Plate Road depot in Knox. Bass Lake, a nearby tourist destination, was a popular draw for people from nearby metropolises such as Chicago or South Bend. Hotels at Bass Lake operated taxis for such vacationers. The passenger train heads east toward Fort Wayne and eventually Buffalo, New York. (Courtesy of the Starke County Public Library.)

IMAGES
of Rail

RAILROAD DEPOTS
OF NORTHERN INDIANA

David E. Longest

ARCADIA
PUBLISHING

Published by Arcadia Publishing
Charleston SC, Chicago IL, Portsmouth NH, San Francisco CA

Printed in the United States of America

Library of Congress Catalog Card Number: 2006935616

For all general information contact Arcadia Publishing at:
Telephone 843-853-2070
Fax 843-853-0044
E-mail sales@arcadiapublishing.com
For customer service and orders:
Toll-Free 1-888-313-2665

Visit us on the Internet at www.arcadiapublishing.com

*I dedicate this book to my family and thank them for their support
in my work. I also dedicate this book to the men and women of Indiana
who chose railroading as their vocation. I hope they thoroughly enjoy
reading about the buildings that are familiar to them and seeing
images of places at which they may have labored.*

CONTENTS

ACKNOWLEDGMENTS

Locating and photographing old railroad buildings was certainly made easier because of the Web site of Mark Camp. His Web site covers the United States in its entirety and provides the researcher with information about the general location of these structures, their date of construction, the name of the operating railroad and its current use or condition. The Web site lists depots, freight houses, bridges, towers, and other railroad information.

I wish to acknowledge the work of Francis H. Parker and his book, *Indiana Railroad Depots: A Threatened Heritage*. Parker's book provides basic information about depots and freight houses. It also includes several photographs to help in identifying structures.

I thank the following people for providing me with photographs of depots or other railroad related images: John Fuller, Robert Albert, Jeff Strombeck, John Strombeck, Robert Spaugh, and Sanford A. Goodrick Jr. I appreciate their labor of love in producing these visual images of so many railroad buildings and structures. I also thank Beth Oljace, Indiana Room librarian at the Anderson Public Library, for providing early images of Anderson and information received from Larry Clark, head of the Porter County Public Library Genealogy Department. I thank Marv Allen, historian of the Starke County Historical Society, who provided me with historical information and vintage photographs. I wish to thank Shan Sheridan of the Frankfort Chamber of Commerce for providing me with a tour of the Frankfort Nickel Plate yard.

I also want to thank Ron Marquardt of the Monon Railroad Historical-Technical Society for helping me acquire a number of the society's excellent photographs. I will acknowledge their photographs as follows: (Courtesy of MRHTS.)

I also want to thank the countless librarians, historical society members, and railroad enthusiasts who responded to e-mails or telephone calls, as I researched northern Indiana.

Photographs and images that are not otherwise credited were taken by the author.

INTRODUCTION

Searching for depots and freight houses in northern Indiana was at times a real challenge. Being from New Albany, I was not familiar with many areas north of Indianapolis. Yet driving the highways of this area was also an adventure. Let me explain.

The challenge often came when I was in areas completely foreign to me. I can recall searching for the Big Four depot in Anderson and knowing I was close; yet also knowing that I had no idea whether to turn right or left to get there. I would then ask for help. I am talking about divine help. At other times I used the resources made available to me. While I was driving through Mishawaka, I got so confused that I was not sure if I was going north or south. I thought, "Who could get me turned in the right direction?" I then saw a Mishawaka Chief of Fire Department vehicle going in my direction. I took flight and followed. I then saw his intended destination; the district fire station. As he was entering the building, I quizzed him and received the directions I needed.

The adventures came with my having a purpose to drive the roads of the state that I love. I thoroughly enjoyed stumbling upon famous industries, noted high schools, and other landmarks that I had read about earlier in life. I would come to towns and cities that were familiar to me because my father had mentioned them for their famed success in basketball. It was during the search that the challenge aligned itself with the adventure. As it turned out, searching Indiana was the adventure.

Depots were an exciting gateway to many Hoosier towns and cities that were served by railroads. It was often the initial contact point between the local community and the outside world and it was also where we saw our youth head off to the state university. Local farmers and manufacturers were both dependent upon the railroad to ship their crops and products, respectively, to various regional markets. It was a place for men to congregate. Yes, even gossip. People traveled across country by rail, and they used the railroad to conduct business and to make needed sales contacts. In the early years of railroading, doing business was cumbersome because of breakdowns and scheduling problems. However, as the trains became more polished and fancy, the traveler could get some needed work accomplished. They may have even found time to rest while traveling. In its heyday, train travel was quite a splendid and costly way to travel.

Today many towns that were once served by one or more railroads have none. Hundreds of miles of track have been torn from the land and the land has been returned to agricultural and recreational use, such as farmland or walking trails. Railroad stations that were once a vital part of the community have disappeared too. As the railroad business shifted from local deliveries to

long haul, the depots were no longer needed and many were demolished. Fewer than 250 depots remain today across Indiana.

Many of the book's chapters are divided by regions so that one can locate, appreciate, and if desired, seek and photograph these structures. Other chapters focus upon certain aspects of railroading that are unique to northern Indiana. The cities and towns still served by Amtrak will be discussed. Amtrak once traveled over southern and northern Indiana tracks but this was reduced in 2003. Now Amtrak only travels the central and northern parts of the state.

Another aspect of railroading that deserves its own chapter is the South Shore Line. Formerly called the Chicago, South Shore and South Bend Railroad, it is now under the management of the Northern Indiana Commuter Transportation District. The Chicago, South Shore and South Bend Railroad is all that remains of what was once a strong interurban rail business in the Hoosier state. I will also focus on a class three, or short line railroad, serving the northern part of our state.

The focus of this book is on the depots and freight houses that had a part in weaving the railroad fabric of Indiana. Some depots are still standing; some are not. As for the buildings that are no longer standing, the book presents a visual memory of a place of importance during a time nearly forgotten. As for the depots still standing, the book presents challenges. How can they be protected? Can they be recycled?

I will discuss the function of depots and provide photographs of items related to that function. In these photographs I will include other areas of railroading such as bridges, train yards, and of course locomotives and rolling stock. The rail structures reviewed in the book will mostly include areas north of Marion County.

The final chapter deals with efforts of preservation and reclamation of railroading. A few railroad buildings are all we have left of a time when people depended on the railroad for personal travel needs and for receiving their shipped parcels. We can no longer see the conductors, clerks, and ticket agents working at the depots, but there are special volunteer groups doing very special things to help preserve that way of life. The final chapter will expose some of those groups and the communities in which they are working. Today's youth knows very little about the role that railroading played in America's past. Trying to grow an appreciation of this history has been made easier with the actions of museums and their many volunteers.

The important thing is that we learn about our communities and the history of their buildings. We need to try to be creative in reclaiming or recycling these structures, before they are all gone. Many depots have been turned into places of business, special meeting places, and local museums, through the hard work of those who have strong feelings for railroads and history. Yet some sit vacant, waiting for the bulldozer. It is important that those who enjoy railroading and its history be active within their communities and try to protect these structures. In writing this book, I hope to remind readers that there may be buildings in their communities worth learning about and preserving.

One

NORTHEASTERN INDIANA

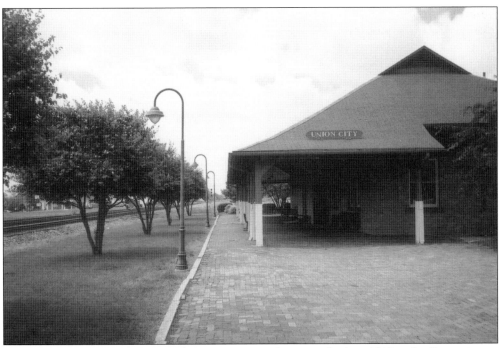

UNION CITY DEPOT. This Pennsylvania passenger depot was built in 1913 and still remains on Howard Street in this Ohio border town, Union City. This structure is listed on the National Register of Historic Places. Thanks to the Art Association of Randolph County, it has been restored and is being used by the community for performances, juried art shows, photography exhibits, and other arts events. The Pennsylvania Railroad wooden freight house was torn down prior to 1985.

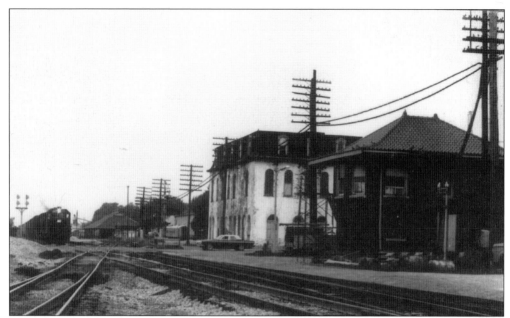

UNION CITY TOWER. This image shows the Cleveland, Cincinnati, Chicago and St. Louis Railroad (Big Four) tower in Union City. This tower is no longer in use but can be seen here to the immediate right of the diesel heading toward the Ohio state line. Union City was the starting point of the Big Four railroad's stretch of rail line that proceeded on to Indianapolis. (Photograph by John Fuller.)

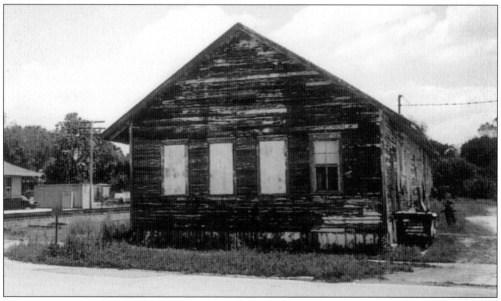

WINCHESTER FREIGHT HOUSE. Winchester was a small but busy town with enough rail business that it required a freight house and a passenger depot. The Cleveland, Cincinnati, Chicago and St. Louis Railroad freight house is located on North East Street and is being used for storage. It is a wood-frame structure that was built in 1912. The nearby tracks are still in use by CSX Railroad, which was formed in 1980 with the merger of the Cessie System and the Seaboard System.

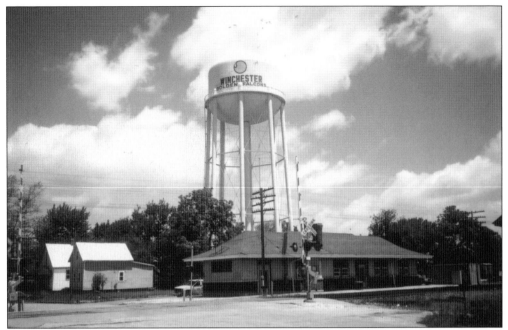

WINCHESTER PASSENGER DEPOT. The Cleveland, Cincinnati, Chicago and St. Louis Railroad passenger depot is located at the corner of North East Street and Railroad Avenue in Winchester. It was built in 1907 and moved to the present site before 1929. CSX Railroad now uses these tracks. This depot is a frame building and has a brick exterior up to the bay window.

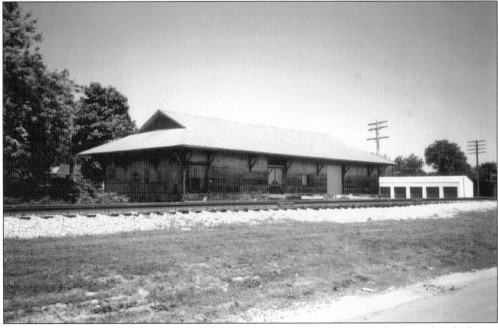

DUNKIRK FREIGHT HOUSE. The Pittsburgh, Cincinnati, Chicago, and St. Louis freight house is now used by a business. It is located on Center Street near Main Street in Dunkirk. It is a wood frame with board-and-batten siding. The nearby tracks are in use. At the corner of Lincoln Avenue and Franklin Street is the passenger depot. It is a private residence.

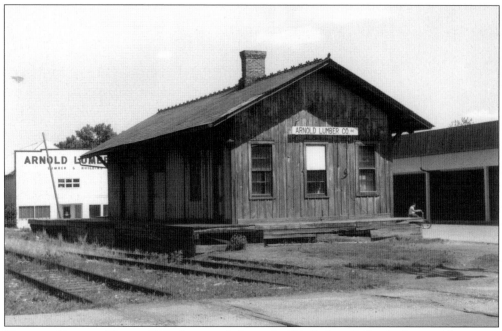

DECATUR FREIGHT HOUSE. This photograph shows the Erie Railroad's freight depot in Decatur as it looked in May 1981. It is located near the Arnold Lumber Company who uses it to store lumber and other building materials. It was built in 1882 and has a wood frame with board-and-batten siding. (Photograph by Jeff Strombeck.)

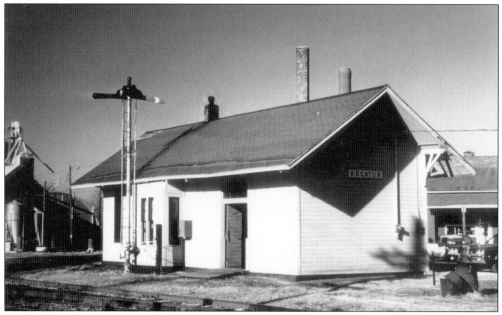

DECATUR NICKEL PLATE. This trackside photograph shows the Decatur Nickel Plate Road depot as it was in December 1973. The depot was located at the Winchester Street crossing. The photograph gives a good look at a semaphore signal. These signals are used to indicate information such as blocked track, safe traveling speed, and permission to proceed or not to proceed. (Photograph by John Strombeck.)

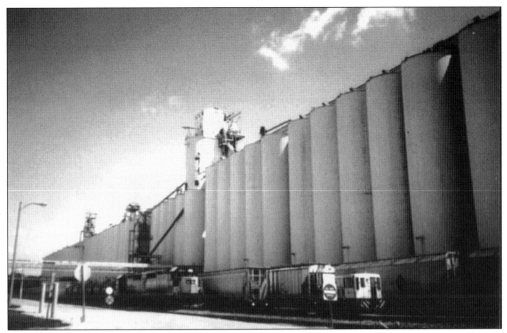

DECATUR GRAIN ELEVATOR. Near the Erie depot in Decatur is this large grain elevator. Several grain hopper freight cars are lined up ready to move the grain with the aid of the small yard switcher. CSX Railroad now uses this rail line. This photograph was taken in the summer of 2004.

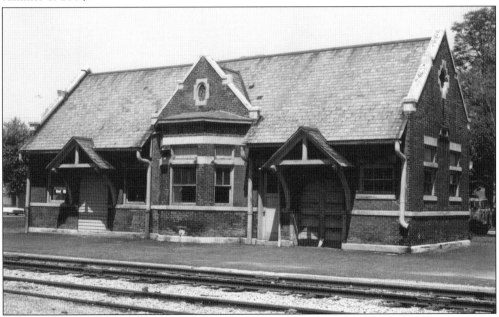

DECATUR GRAND RAPIDS AND INDIANA. This Grand Rapids and Indiana Railway depot is located at 111 North Seventh Street in Decatur. It was built in 1902 and now houses a business called Gandy Dancers. The Pennsylvania Railroad eventually absorbed the Grand Rapids and Indiana Railway. The depot has since been restored and an addition has been added. This photograph was taken in 1981. (Photograph by Jeff Strombeck.)

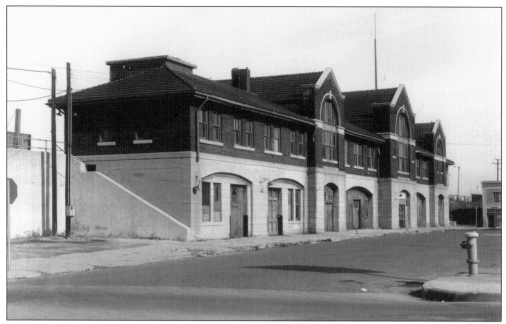

FORT WAYNE PENNSYLVANIA AND WABASH. This photograph was taken in 1973 and shows the depot that was shared by the Pennsylvania and Wabash Railroads. The two-story structure was located between Calhoun and Harrison Streets in Fort Wayne. The architect used the arch extensively over the doors and windows. It was torn down in the 1970s. (Photograph by John Strombeck.)

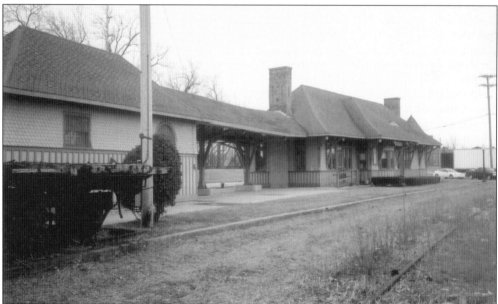

FORT WAYNE PASSENGER STATION. This great looking building is the Lake Shore and Michigan Southern passenger depot. It is located on the corner of Cass Street and Wells Avenue just north of the St. Mary's River in Fort Wayne. It is a frame structure with siding and chimneys on each end. It is of a Queen Anne style and was built in 1889. There is a separate express building on the end connected by a canopy.

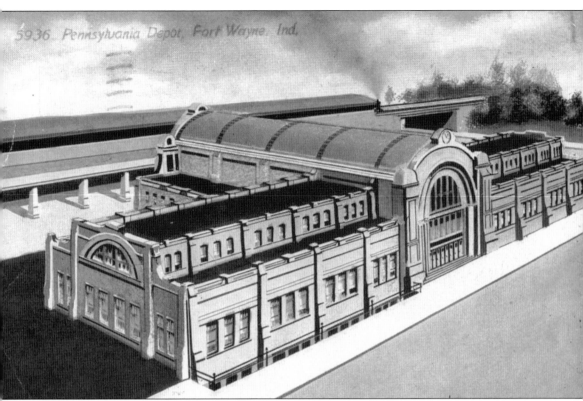

5936 Pennsylvania Depot, Fort Wayne, Ind.

FORT WAYNE PENNSYLVANIA STATION. This postcard shows the Fort Wayne Pennsylvania Railroad passenger station at 231 West Baker Street. It was built in March 1914, at a cost of $550,000. To many travelers, it was the gateway into Fort Wayne. Fort Wayne was a major division point for the Pennsylvania Railroad and, at one time, employed over 1,000 men in the railroad car shops. From its beginning, the station was the largest and grandest of Fort Wayne's passenger stations. In more recent times, it was used by Amtrak. The Amtrak service lasted until November 1990 when the Broadway and Capitol Limited trains were rerouted. The east and west wings have been renovated for use by several businesses and offices. The concourse is open to the city for community events. The Baker Street Station is listed on the National Register of Historic Places. This postcard has a 1912 postmark. (Produced by Charles A. Phelps Company.)

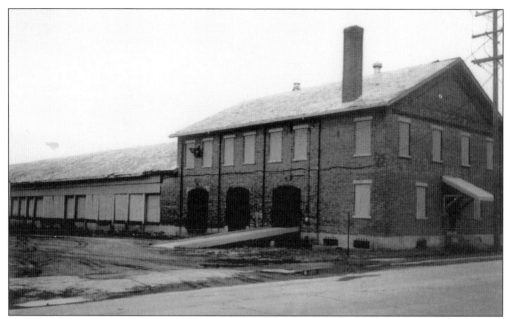

FORT WAYNE FREIGHT HOUSE. The Lake Shore and Michigan Southern freight house is a huge structure located at the corner of Fourth Street and North Clinton Street about four blocks from downtown Fort Wayne. It was built of brick in 1913. This freight depot was used jointly by the Lake Shore and Michigan Southern and the Lake Erie and Western Railroads. It is now used by OmniSource for storage.

FORT WAYNE AND THE INTERURBAN. This was the Indiana Service Corporation freight house and is at 222 Pearl Street in Fort Wayne. This two-story brick structure was built between 1914 and 1918. Today it is home to Gallinger Photography. Fort Wayne also had a large Indiana Railroad System freight terminal on Commerce Drive that has been demolished. Fort Wayne was a main connection in Indiana's interurban system.

FORT WAYNE AND THE INDIANA RAILROAD. There is a five-story brick building on the corner of Pearl and Harrison Streets in Fort Wayne that was an interurban freight station for the Indiana Railroad. It is currently called the Randall Building. The Indiana Railroad connected Fort Wayne to these and other Indiana cities: Peru, Logansport, Lafayette, Blufton, Marion, and Waterloo. The 1929 stock market crash had great impact on the interurban railroads, and by 1933, the Indiana Railroad entered bankruptcy.

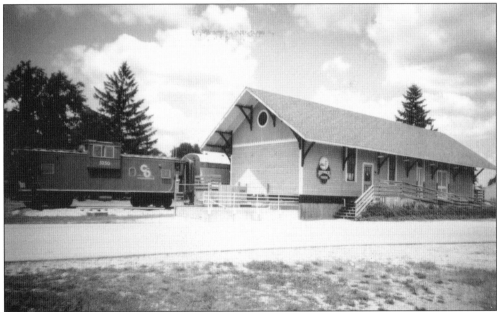

GARRETT FREIGHT HOUSE. The Garrett Historical Society has restored and relocated this Baltimore and Ohio Railroad freight house. It now serves the community as a museum with various railroad artifacts and photographs. Part of the museum is used as a model railroading display and another portion is used as a meeting room for the society. It was constructed of wood in 1900 and is now located on North Randolph Street.

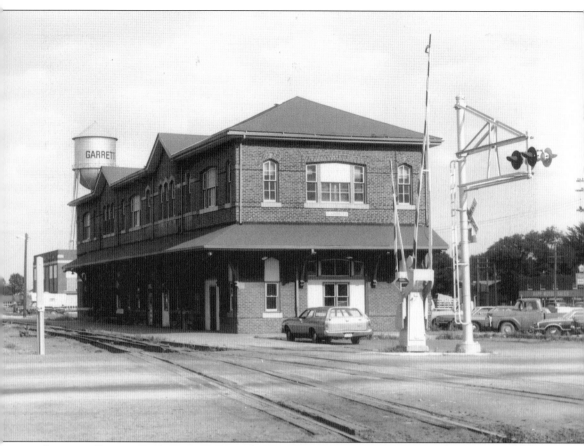

GARRETT PASSENGER STATION. Garrett has quite a rail legacy and was at one time the home for car shops, a large roundhouse, an engine facility, the freight house, and this passenger station. Garrett was founded in 1875 by the Baltimore and Ohio Railroad and named after John Garrett, the Baltimore and Ohio Railroad president. At one point, when the town's population was 5,000, about 1,300 male residents were employed by the Baltimore and Ohio Railroad train shops. In many small Indiana towns, like Garrett, the railroad had a tremendous influence on the local economy. This Garrett passenger station was demolished in 1995. At one time, this passenger station was a stop on Amtrak's Broadway Limited route, which was later called the Three Rivers route. Garrett was certainly a major town on the Baltimore and Ohio's rail line. This photograph was taken in 1974. (Photograph by Jeff Strombeck.)

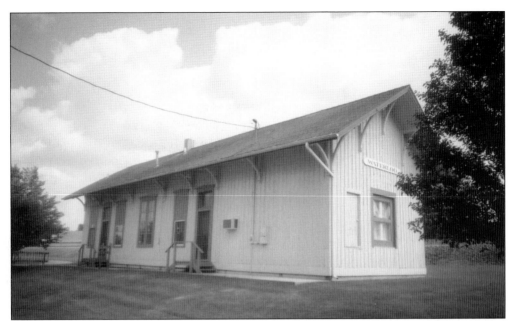

WATERLOO COMBINATION DEPOT. This is the Lake Shore and Michigan Southern Railroad combination depot located on Van Vleeck Street in Waterloo. It was built in 1883 and has been restored. It is a frame structure with board-and-batten siding. The track is in use by the Norfolk Southern Railway. This is also the site of an Amtrak waiting shelter that will be shown in chapter 6. This photograph was taken in 2004.

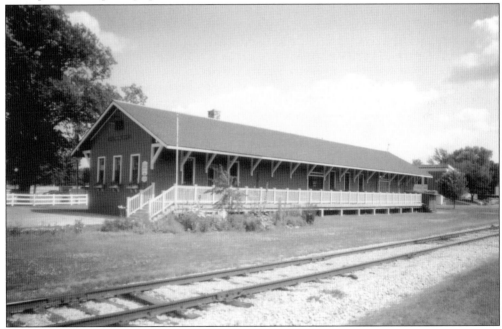

ANGOLA FREIGHT HOUSE. A Lake Shore and Michigan Southern freight house is located at 611 West Maumee Street in Angola. It has been restored and is in use today by a business. It is a frame structure with board-and-batten siding and was constructed in 1911. The accompanying tracks are now used by the Indiana Northwestern Railroad. This photograph was taken in 2004.

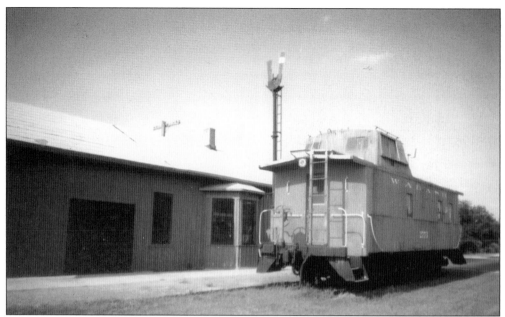

TOPEKA WABASH DEPOT. This combination depot is near Main Street on Indiana Street in Topeka. It is a frame structure with board-and-batten siding. It was initially built in 1893 and rebuilt in 1911 and has been altered in length. The Topeka Depot is a historic landmark and museum preserved by the Topeka Area Historical Society. A Wabash caboose and a semaphore are part of a static display at the depot.

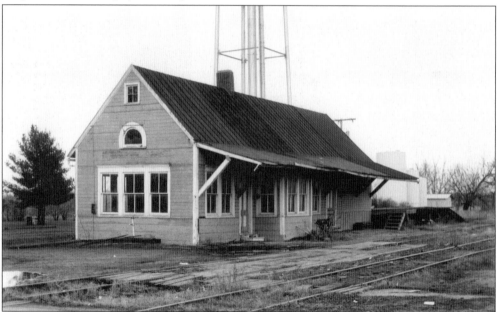

SHIPSHEWANNA COMBINATION DEPOT. This Lake Shore and Michigan Southern Railroad depot was used for passengers and freight. It was built between 1888 and 1889 and is located at the corner of Morton and Depot Streets in Shipshewanna. This photograph was taken in 1973, before several alterations were made to the structure. Today there is a caboose on the property in front of the restored depot. It is now a business; the Galarina Arts Shop. (Photograph by Jeff Strombeck.)

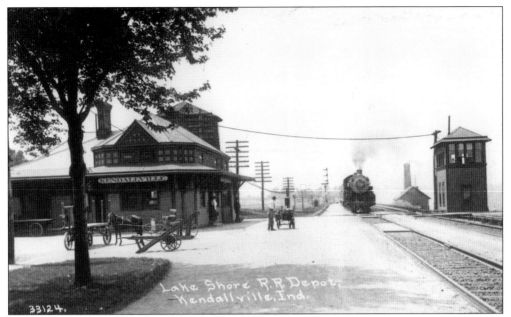

KENDALLVILLE DEPOT. This Lake Shore and Michigan Southern depot was once located at Kendallville. This depot had two stories and a rail tower across the tracks. The Lake Shore and Michigan Southern Railroad merged in 1915 into the New York Central Railroad. This image is a copy of an old postcard showing a steam locomotive chugging toward the depot and an unattended carriage in front of the depot. The building was torn down prior to 1985. (Courtesy of the Hoosier Valley Railroad Museum.)

WAWAKA COMBINATION DEPOT. The building in the center is a Lake Shore and Michigan Southern combination depot. It was built in 1873 in Wawaka and is located at 123 Depot Street behind several agriculture related buildings near the tracks. The Lake Shore and Michigan Southern Railroad often combined depots and grain houses in smaller towns. The building is now used for storage and was constructed of wood with board-and-batten siding.

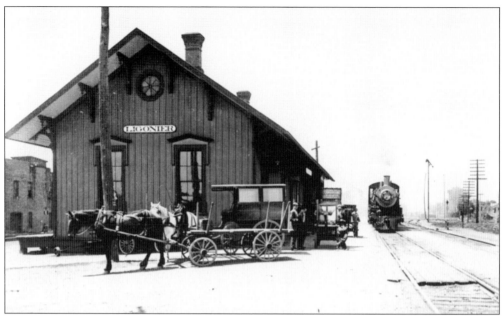

LIGONIER DEPOT. At Ligonier is yet another Lake Shore and Michigan Southern depot. This grand photograph shows a steam locomotive approaching the depot and a horse-drawn carriage possibly awaiting people and their parcels. Notice the boards that were put down between the tracks to make it easier for travelers to walk across. This depot was torn down in 1963. (Courtesy of John Strombeck.)

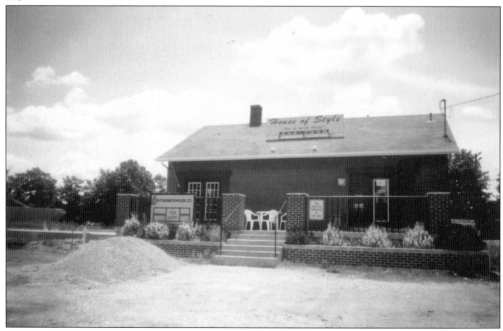

COLUMBIA CITY PASSENGER DEPOT. On Chicago Street in Columbia City is this Pennsylvania Railroad passenger depot. Built in the late 1940s, this brick building has been altered with an addition and other changes. A business called the House of Style was using the depot in 2004. This recycled depot seems to have found a new life.

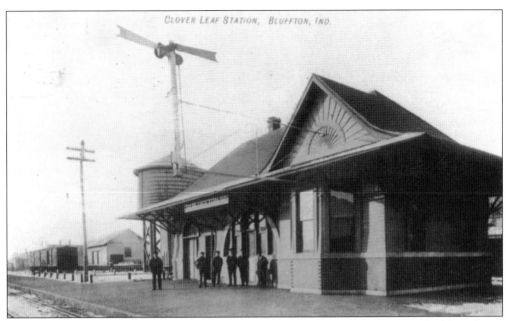

BLUFTON CLOVER LEAF STATION. This depot in Blufton has a somewhat unique building design that can be seen in other Hoosier towns such as Veedersburg and Marion. They are all similar in that the architect liked to use the arch is the designs. The depot was built in 1903. This depot was demolished in January 1991. (Courtesy of Robert Albert.)

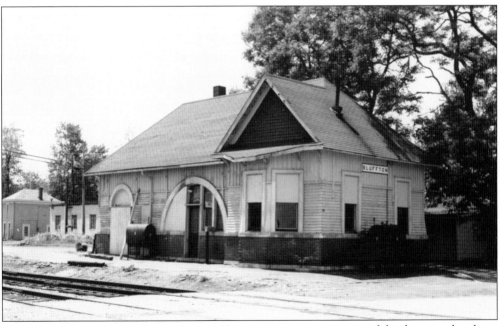

BLUFFTON NICKEL PLATE ROAD DEPOT. Here is a more recent image of the depot in the above postcard. Here it is referred to as a Nickel Plate depot because the Clover Leaf was later merged into the Nickel Plate Road. This photograph shows the alterations that have occurred such as the changes in the roofline. In January 1991, the depot was demolished, 10 years after this photograph was taken. (Photograph by Jeff Strombeck.)

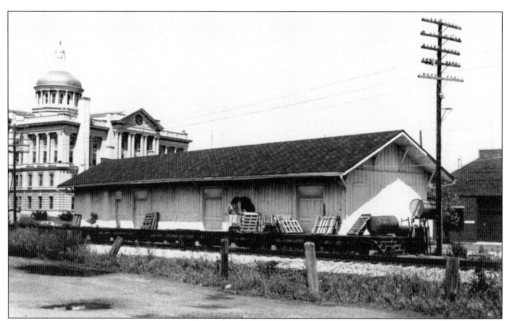

HUNTINGTON FREIGHT HOUSE. A pizza restaurant now occupies the old Wabash Railroad freight house in downtown Huntington. It is located at 297 Court Street and was built in 1887 by the Wabash, St. Louis and Pacific Railroad. It is a wooden structure with board-and-batten siding. To the left is a great view of the Huntington County Courthouse. This photograph was taken in 1981. (Photograph by Jeff Strombeck.)

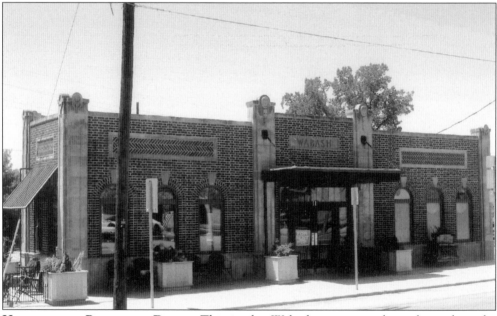

HUNTINGTON PASSENGER DEPOT. This is the Wabash passenger depot located at the intersection of State and Jefferson Streets in Huntington. It is constructed of brick and limestone and was built in 1928. It has a flat roof and is currently located on a very small property. Built in 1928, it is an example of neoclassical architecture. This image was shot in 2006 when the depot was vacant.

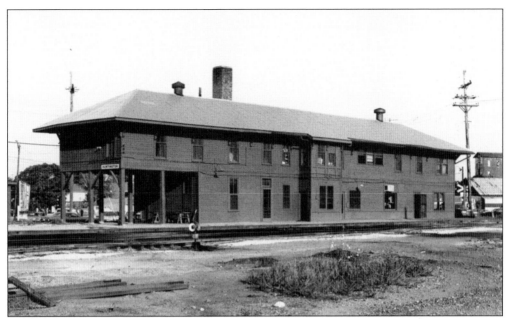

HUNTINGTON DIVISION DEPOT. This large two-story wooden structure was the Erie-Lackawanna Railroad's division point depot. This image was taken in 1973 and the building was demolished prior to 1985. The Erie-Lackawanna was a north–south line through Huntington. Since Huntington had been a crew change point, there remain some former Erie-Lackawanna employees living here today. (Photograph by Jeff Strombeck.)

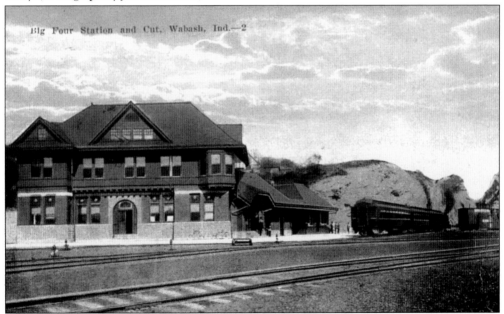

WABASH STATION. This vintage postcard shows the three-story Big Four Wabash station before its demolition. It was constructed of brick with a stone course belt. These old cards often show great detail including the people standing near the station, the two bicycles leaning against the station, the stone cut created to lay the track, and the old rail coaches. (Produced by E. C. Kropp Company.)

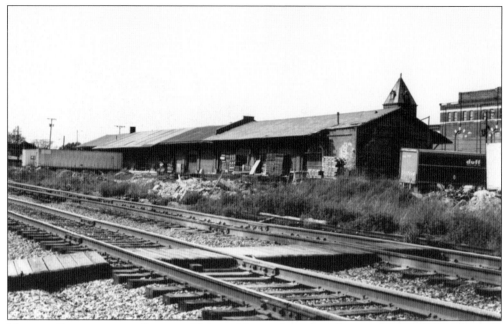

MARION PENNSYLVANIA FREIGHT HOUSE. Marion has a long history as a manufacturing city with several automobile parts factories. This Pennsylvania Railroad freight house is located at 520 Lincoln Boulevard and was built of brick in 1902. It is currently being used as a truck terminal. The photograph was taken in 1981. (Photograph by Jeff Strombeck.)

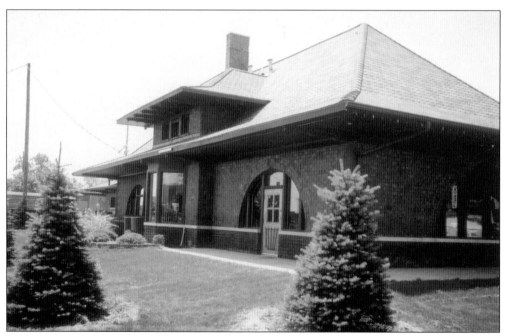

MARION PASSENGER. Marion, being an industrial city, was dependent upon the railroads. This Toledo, St. Louis and Western brick passenger depot is at the corner of McClure and East Fourth Streets. This structure exhibits attractive use of the arched windows and doors. It was built in 1900 and has been converted into a Mexican restaurant. It has been well maintained over the years.

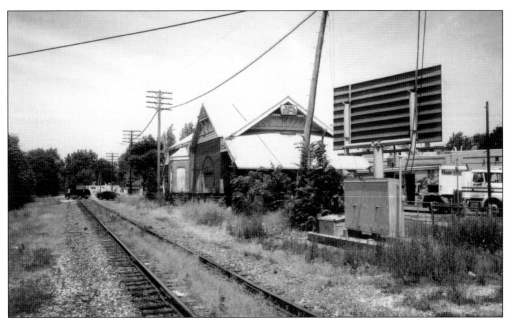

MARION PENNSYLVANIA PASSENGER. At the corner of South Washington and West Tenth Streets is the Pennsylvania Railroad passenger depot in Marion. It was built in 1895 of brick and is now a neighborhood liquor store. Often what becomes of an old structure depends on its location in the city. This building has been altered in several ways including the roof awning system and the exterior grounds.

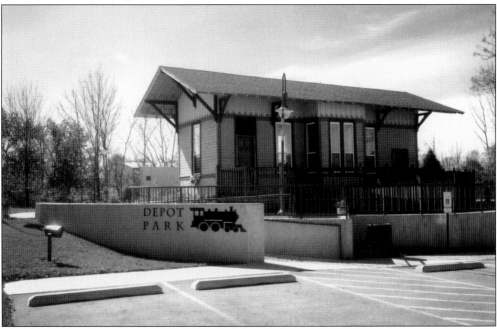

UPLAND DEPOT PARK. This Pennsylvania Railroad depot in Upland has been greatly refurbished and is a focal point at Depot Park, located at the south edge of town. It is a wood-frame structure with wood siding. Upland is home to Taylor University, and the Pennsylvania Railroad passenger train moved students to and from campus for many years.

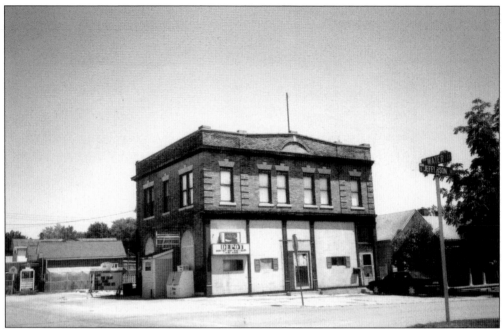

HARTFORD CITY. This Indiana Union Traction interurban depot in Hartford City is of the same Union Traction architectural plan as the structures in Tipton and Noblesville; however, it has survived more alterations. It is located on the corner of Jefferson and Water Streets and was constructed of brick in 1908. It is a two-story building and is now used as a residence and business.

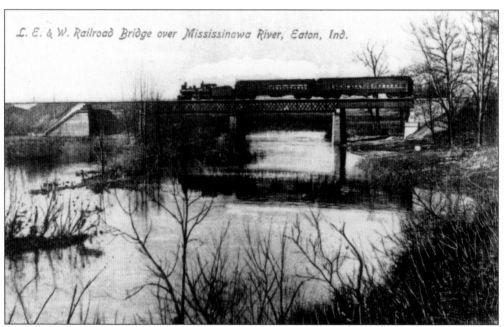

EATON RAILROAD BRIDGE. This print of an old postcard shows the wintry scene of a steam locomotive churning across the Mississinawa River on the Lake Erie and Western Railroad bridge. This short passenger train included only a coal tender and two coaches. Eaton is located north of Muncie and east of Indiana State Highway 3. (Courtesy of Robert Albert.)

MUNCIE FREIGHT HOUSE. The Cleveland, Cincinnati, Chicago and St. Louis Railroad freight house in Muncie is still in use. This rather large brick building is located at 800 South Liberty Street and was built in 1920. As was the custom with some rail lines, one end of the structure was two stories and used for offices and the single-story portion was for shipping and receiving freight.

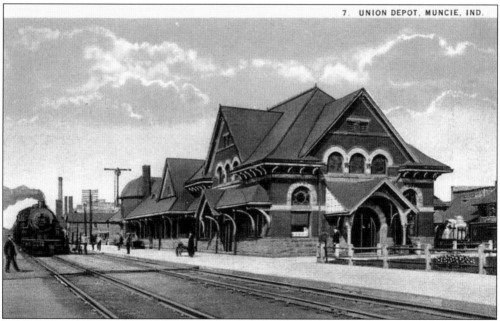

MUNCIE UNION STATION. This vintage postcard shows a view of the Union Station in Muncie that served the Nickel Plate and the Big Four Railroads. The building is primarily red brick and has two sets of tracks in the foreground and another set of tracks on the other side of the depot. People can be seen unloading a steam locomotive–pulled train car. (Produced by Harry H. Hamm Company.)

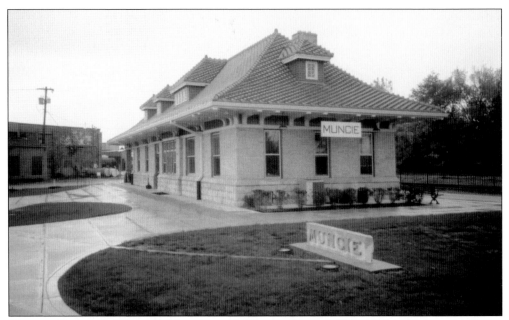

MUNCIE PASSENGER DEPOT. This restored Chesapeake and Ohio Railroad passenger depot was built in 1901 and is located at 700 Wysor Street in Muncie. It is now a part of the Cardinal Greenway and the White River Greenway project that builds and maintains walking trails on abandoned railroad track beds. The Cardinal Greenway Rail Trail will extend from Richmond to Marion, connecting five central Indiana counties.

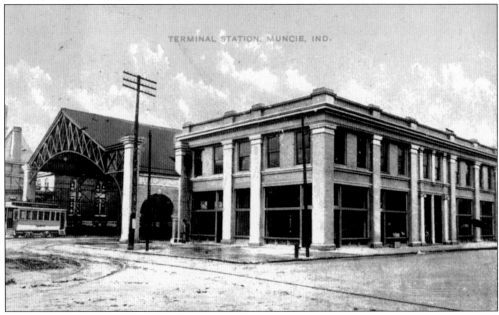

MUNCIE TERMINAL STATION. The Muncie Street Railway Company began operation in 1889 and then became part of the Union Traction Company of Indiana in 1899. The postmark on the back of this postcard has a date of 1903, a time when the interurbans trolleys were going strong. The card shows both the carbarn and the terminal offices. Streetcars were discontinued in Muncie in 1931. (Produced by S. H. Knox and Company.)

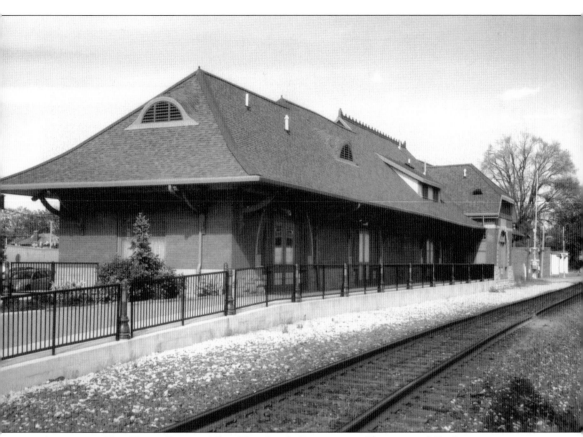

ANDERSON BIG FOUR DEPOT. The Cleveland, Cincinnati, Chicago and St. Louis passenger depot is located on Dillon Street between Main and Meridian Streets. It was built in 1887, and according to a 1919 Interstate Commerce Commission Valuation Report, it is a Type VII pressed brick and stone foundation station. It was built by the Indianapolis and Bellefontaine Railroad, which was the predecessor of the Cleveland, Cincinnati, Chicago and St. Louis Railroad. The depot was used as a passenger station from its construction in 1887 until 1971 when the last passenger train left the depot. The building was boarded up and left to decay for nearly 10 years. The remodeling of the Big Four depot was completed in October 2003. It has been in use since 1985 by the Anderson Young Ballet Theatre. The tracks are now being used by the CSX Railroad. This trackside photograph was taken in 2004.

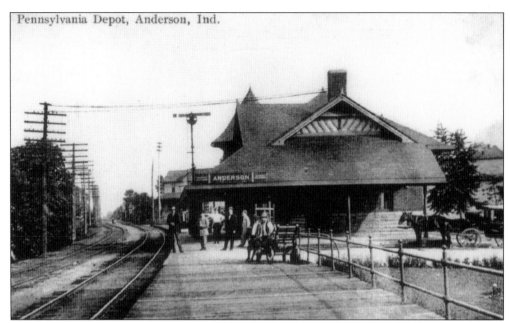

ANDERSON PENNSYLVANIA DEPOT. The old Pennsylvania Panhandle Railway station, shown in this postcard print, was located at Ninth and Fletcher Streets in Anderson. In its latter years of existence, the depot was used as a nightclub and discotheque. In the early 1970s, the Panhandle station burned to the ground, leaving only the previously mentioned Big Four depot as a reminder of Anderson's rail history. (Courtesy of the Anderson Public Library.)

FRANKTON DEPOT. This "Class C" Pennsylvania Railroad combination depot is in Frankton and is a frame building with siding. One can see the same design in the depot at Rockville in Parke County. The station has been moved from its original location. It was built in 1892 and is on Lafayette Street.

Two

NORTH CENTRAL INDIANA

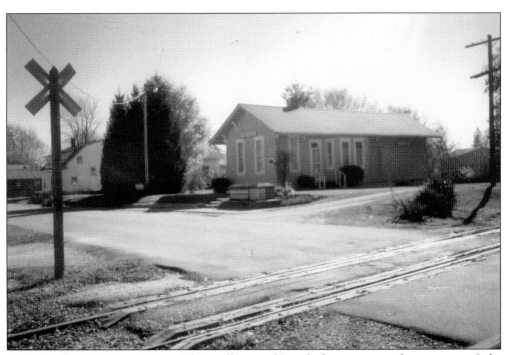

ARCADIA COMBINATION DEPOT. The small town of Arcadia has a museum that once was a Lake Erie and Western Railroad combination depot. It has been relocated to 107 West South Street and is again located next to railroad tracks. This is a wooden structure with frame construction and board-and-batten siding and was built between 1869 and 1876. It is now used as the Heritage Center Museum and the Arcadia Branch Library.

NOBLESVILLE UNION TRACTION. This two-story building was used by the Indiana Union Traction Company as an interurban combination depot. It is located on the corner of Clinton and Ninth Streets in Noblesville. The same building design was used in Tipton at the Indiana Union Traction structure there. This building was built in 1906. This building is an example of a "storefront" interurban depot.

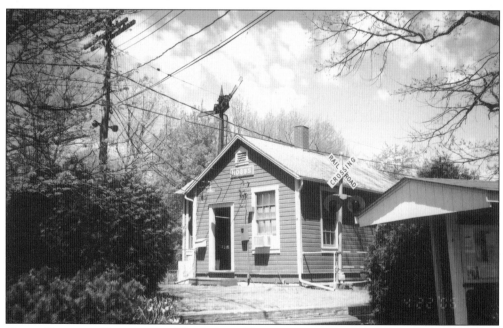

HOBBS DEPOT AT NOBLESVILLE. The Indiana Transportation Museum is located in Forest Park, west of State Road 19, in Noblesville. This photograph shows the Lake Erie and Western Railroad combination depot that was previously located in Hobbs. This depot is a wooden frame structure that was built in 1948. The museum is operated by a very dedicated group of volunteers.

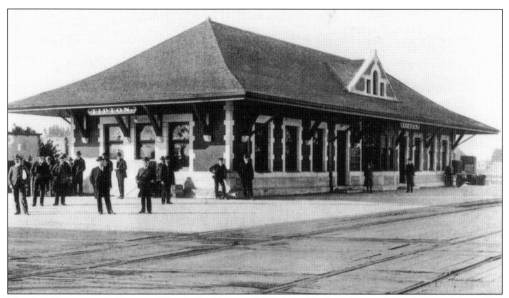

TIPTON PASSENGER DEPOT. This Lake Erie and Western Railroad passenger depot is located at the intersection of North Main and Erie Streets. It was constructed in 1902 of brick with stone courses at the base. In June 1933, Tipton ceased to be the division point as the Lake Erie and Western Railroad moved its operation to Frankfort and combined it with the former Clover Leaf facilities. This attractive design was also used in the Lake Erie and Western Railroad depot in Lafayette. (Courtesy of Robert Albert.)

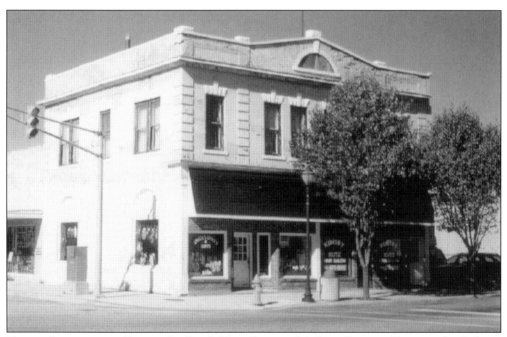

TIPTON INTERURBAN DEPOT. On South Main Street at Madison Street in Tipton is this Indiana Union Traction combination depot. This two-story building was of the same design as the Union Traction storefront depot at Noblesville. The Union Traction line used this same design in other interurban depots. Adding bricks to the arches has altered the windows of this station.

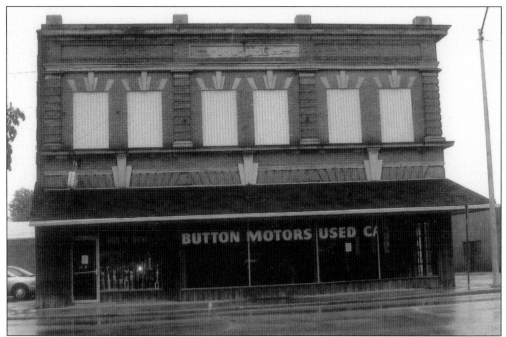

KOKOMO INTERURBAN PASSENGER DEPOT. This Indiana Union Traction interurban passenger station is located on the east side of East Union Street, one block east of the Howard County Courthouse in Kokomo. The current occupant is an automobile dealership. The Kokomo City Street Railway Company began streetcar service in 1891 and ended in 1932 when streetcar service was discontinued.

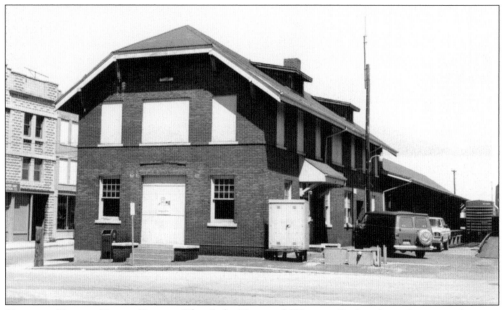

KOKOMO NICKEL PLATE DEPOT. This Lake Erie and Western Railroad combination depot is located on West Jackson Street in Kokomo. It was built in 1916 with a two-story brick passenger area in the front and a one-story freight depot in the rear. This photograph was taken in 1961. Today rolling stock is stored alongside the depot. (Photograph by Jeff Strombeck.)

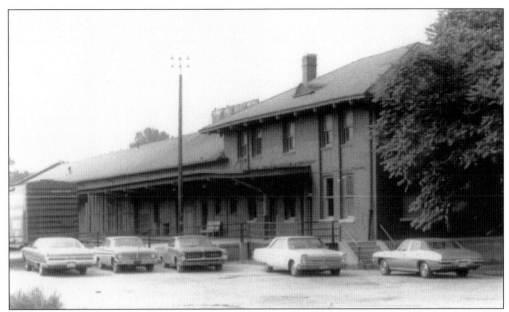

KOKOMO FREIGHT HOUSE. The Pennsylvania Railroad was one of several railroads serving the passenger and production needs of this automobile parts manufacturing city. Railroading began in Kokomo in 1855 with the Chicago and Cincinnati Air Line Railroad. It was merged into the Pittsburg, Cincinnati and St. Louis Railroad, which later merged into the Pennsylvania Railroad. The freight building was demolished sometime after 1976. (Photograph by Ron Stuckey, courtesy of John Fuller.)

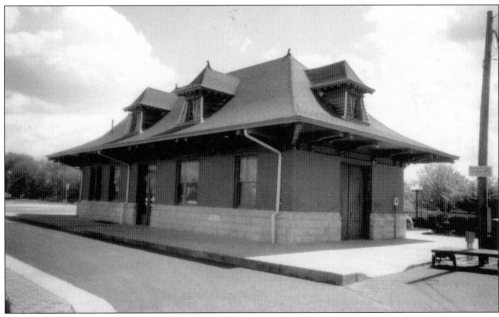

PERU PASSENGER DEPOT. Peru was a division point for the Chesapeake and Ohio and the Wabash Railroads. The brick depot in this photograph was built in 1901. Peru has recently converted this Chesapeake and Ohio Railroad passenger depot into a community center. It has been restored beautifully and is located at the corner of Canal and Broadway Streets.

PERU WABASH DEPOT. This photograph, taken in 1981, shows the Wabash Railroad depot on Broadway Street in Peru. The frame part of the depot is older, having been built around 1873. The Norfolk Southern Railway uses the rails that once led to and from this depot. This depot has been torn down in recent years, but the small railroad building, seen here to the right of the depot, remains. (Photograph by Jeff Strombeck.)

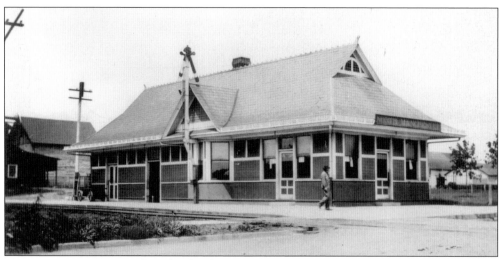

NORTH MANCHESTER. The Cleveland, Cincinnati, Chicago and St. Louis depot in North Manchester is located on Main Street at the tracks. It was constructed in 1904 and is a wood-frame structure. This postcard print gives an accounting of how the depot looked before it was abandoned by the railroad. It was being used as an automobile parts outlet in 2004. (Courtesy of John Strombeck.)

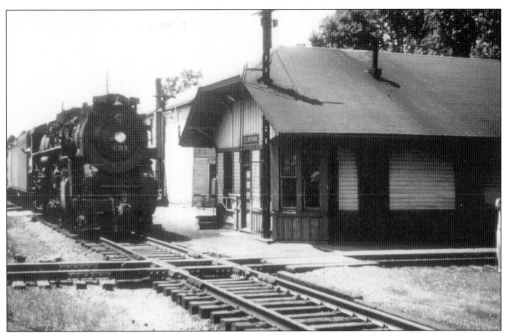

CLAYPOOL NICKEL PLATE DEPOT. This depot was built in Claypool by the Nickel Plate Road. Claypool was on the Nickel District Line between Argos and South Whitley. The photograph shows a steam locomotive at the diamond with the New York Central line. It was taken in 1951. (Photograph by Sandford A. Goodrick Jr.)

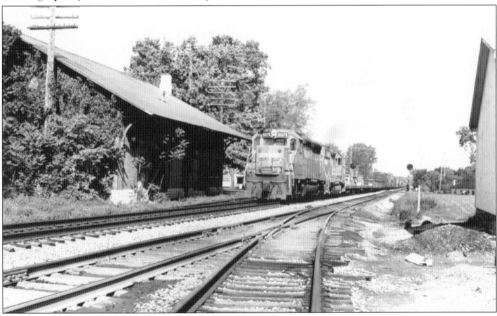

CONRAIL DIESEL AT PIERCETON. This photograph of the Pennsylvania depot at Pierceton shows Conrail diesel No. 6078 heading east on the Chicago to Pittsburgh mainline. The depot, to the left of the engine, was built in 1867 and is located on Market Street. It is the second oldest remaining Pennsylvania System depot in the state and has been restored. The photograph was taken in 1981. (Photograph by Jeff Strombeck.)

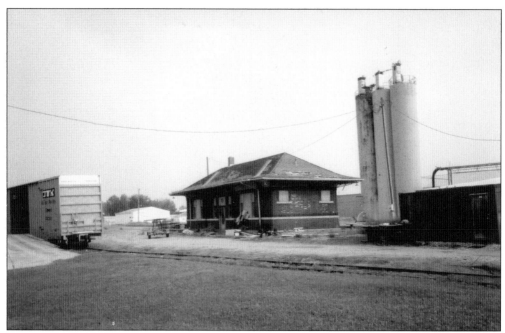

SYRACUSE BALTIMORE AND OHIO PASSENGER. This depot was built in 1913, a year when many Baltimore and Ohio Railroad depots were being improved. It is located on East Medusa Street in Syracuse and is a brick building with a stone belt. A small grain elevator is located south of the depot. The nearby trackage is used by the CSX Railroad.

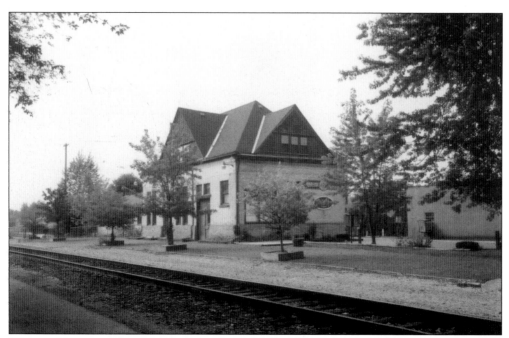

WARSAW PASSENGER DEPOT. The Pennsylvania Railroad built this fine looking depot in 1893. It is a brick depot and has been restored with some alterations. It is located on Lake Street in Warsaw and is now used by the community. The nearby single track is in use by the CSX Railroad.

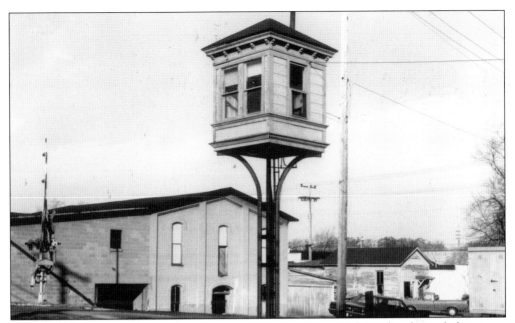

WARSAW PENNSYLVANIA TOWER. Water towers were essential in the days of the steam locomotive. One locomotive used water at a rate of 40 to 60 gallons per mile. The factors that would alter this ration would be the grade of the line, the size of the tender, and the weight of the engine. This photograph of the Warsaw Tower was taken in 1973 before it was torn down. (Photographed by Jeff Strombeck.)

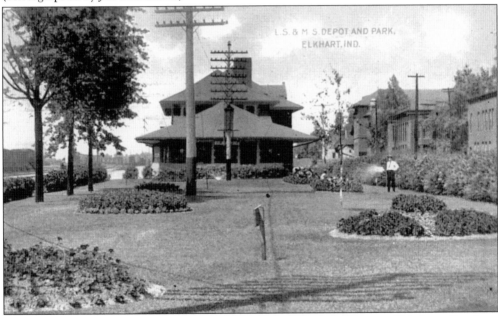

ELKHART PASSENGER DEPOT. This vintage postcard shows the Lake Shore and Michigan Southern Railroad passenger depot located at Tyler and South Main Streets in Elkhart. It has a postmark of 1909 and was mailed to nearby Mishawaka. The depot is two stories and was built in 1900. Elkhart now owns the station and Amtrak uses it for its regional offices. This postcard has no manufacturer's name.

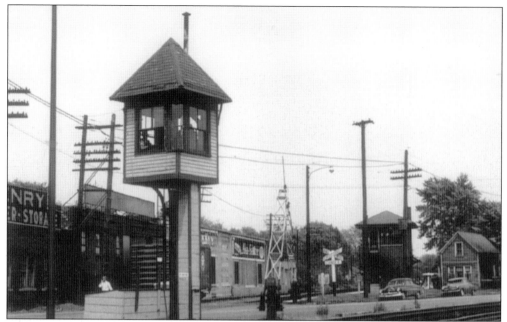

ELKHART CROSSING TOWER. This tower was once located near the Lake Shore and Michigan Southern Railroad station on Main Street in downtown Elkhart. This is still a heavily trafficked area with many vehicles and as many as 100 trains moving across these tracks daily. Elkhart was an important New York Central division point. (Courtesy of the New York Central Railroad Museum.)

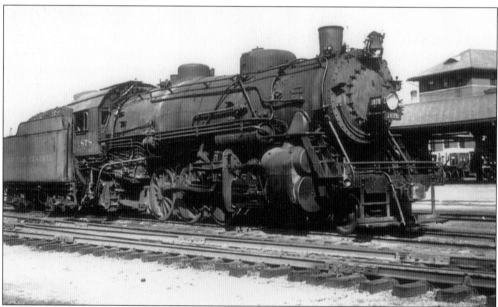

STEAM LOCOMOTIVE NO. 1878. This image shows New York Central steam locomotive No. 1878 and tender heading east through Elkhart. The Lake Shore and Michigan Southern Railroad depot canopy area can be seen to the right of the engine. Above the canopy, one can see the original upper level of the passenger depot. (Photograph by Robert Schell, courtesy of Robert G. Spaugh Sr.)

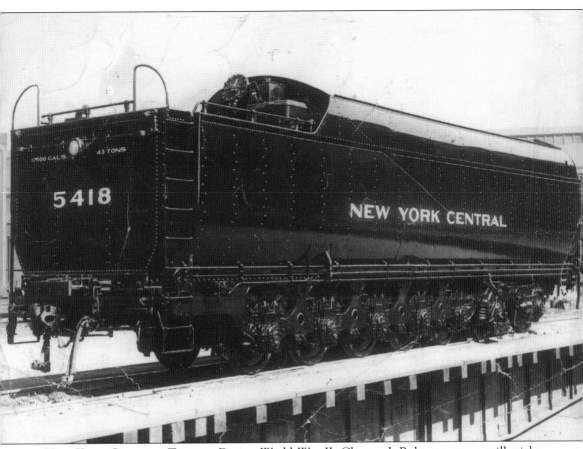

NEW YORK CENTRAL TENDER. During World War II, Clayton J. Roberson was a millwright machinist foreman at the Beech Grove New York Central Railroad shops. One of his assignments was to direct the building of large coal tenders, as seen in the photograph. New York Central tender No. 5418 is shown as it was displayed on a turntable. These tenders had stokers that fed the coal directly into the boiler of the steam engine. They carried a large supply of water that helped make the steam that drove the engine. The facilities at Beech Grove were not able to build the coal cars fast enough for the demand caused by the war. Therefore New York Central Railroad awarded a contract to the Lima Locomotive Works to build several tenders for them. Roberson was a job instructor who helped advise the Lima Locomotive Works in constructing these tenders. (Courtesy of Beatrice Roberson.)

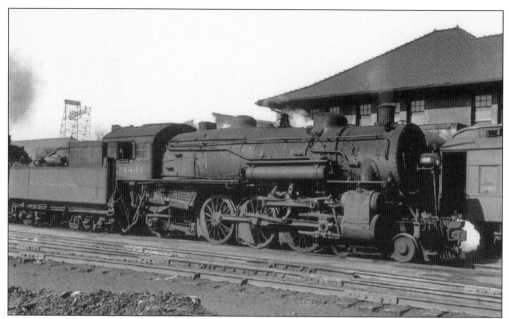

STEAM LOCOMOTIVE NO. 4441. This image shows New York Central Railroad steam locomotive No. 4441 heading east through Elkhart. To the right of the engine, a passenger coach can also be seen on one of several tracks at this station. Directly behind the engine is the upper level of the Lake Shore and Michigan Southern Railroad passenger depot. (Photograph by Robert Schell, courtesy of Robert G. Spaugh Sr.)

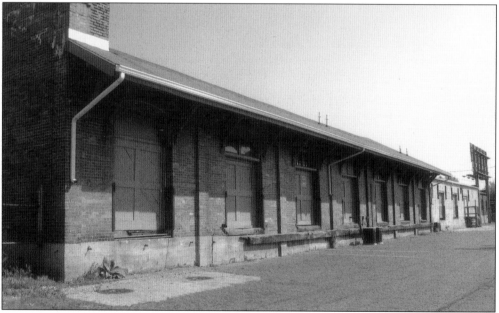

ELKHART FREIGHT HOUSE. The Lake Shore and Michigan Southern freight house is across the tracks from the passenger station at 721 South Main Street in Elkhart. It is now the museum home for the National New York Central Railroad Museum. The freight house was built in 1907. The museum was founded in 1987 and helps preserve both local and national railroad heritage. Visitors may enter the museum through a 1915 passenger coach.

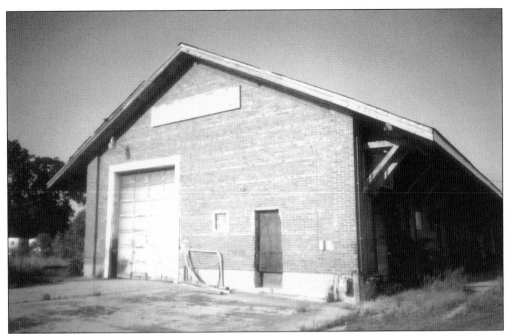

GOSHEN FREIGHT HOUSE. A New York Central Railroad freight depot is located at 605 Logan Street, near the passenger depot, in Goshen. It is a brick structure that was constructed in 1910 and is now used for storage. New York Central was a major railroad in Goshen and neighboring cities such as Elkhart.

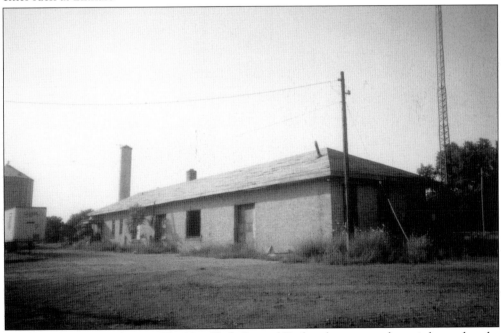

GOSHEN PASSENGER DEPOT. The New York Central Railroad passenger depot is located at the corner of Clinton and Sixth Streets in Goshen. It is a brick station built sometime between 1926 and 1941. Both Goshen depots were built in the heart of a once very rich manufacturing area of the city. The passenger depot appears to be vacant and likely to become even more run down.

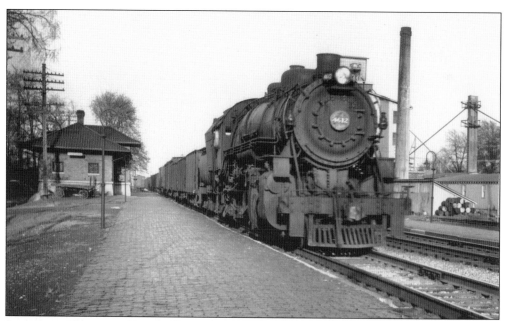

STEAM AT NAPPANEE DEPOT. Steam locomotive No. 4612 is shown here at the Nappanee Baltimore and Ohio Railroad depot heading west. The depot was built in 1910, replacing a wooden frame one that sat just west of it. The depot sits perpendicular to Main Street alongside the heavily used tracks. This terrific photograph was taken several years ago, before the total use of diesels. (Photograph by Robert Schell, courtesy of Robert G. Spaugh Sr.)

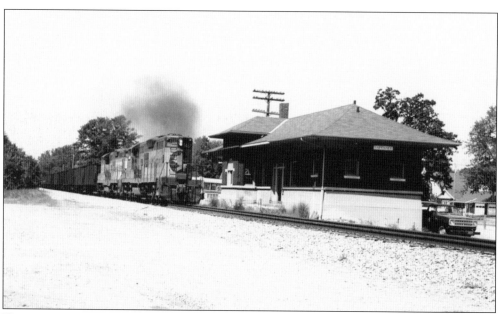

TRANSITION TO DIESEL. Chessie System diesel No. 6427 is shown here at the Nappanee Baltimore and Ohio Railroad depot. Currently the depot houses provisions for a local food drive project. Nappanee is a very active tourist location with specialty shops, antique stores, and other tourist related businesses. This photograph was taken in 1984, while it was still being used as a stop for Amtrak. (Photograph by Jeff Strombeck.)

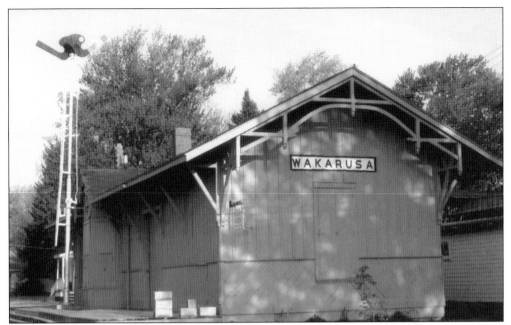

WAKARUSA WABASH DEPOT. A Wabash Railroad combination depot still stands south of Wakarusa. The depot was constructed in 1893 of frame design and of board-and-batten siding. It is now being used as a museum operated by the Wakarusa Historical Society. It has been altered in length and was moved to a different site after its closing.

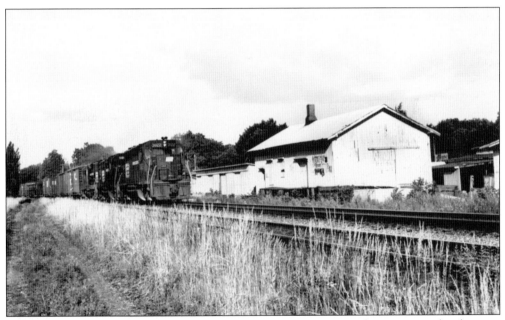

OSCEOLA DEPOT. Penn Central Railroad diesel No. 3022 is seen here passing the depot at Osceola. The Penn Central emblem can be seen on the front of this engine. This former Lake Shore and Michigan Southern Railroad depot in Osceola is located at 350 Washington Street, was on the Chicago to New York mainline, and was constructed in 1871. This photograph was taken in 1976. (Photograph by Jeff Strombeck.)

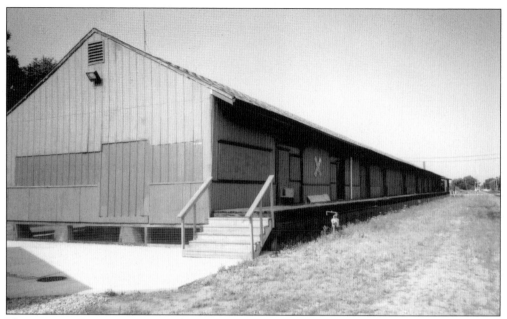

MISHAWAKA FREIGHT HOUSE. This lengthy wood-frame freight house with board-and-batten siding can be found in Mishawaka, in St. Joseph County. The Lake Shore and Michigan Southern Railroad built this building in 1856, and an addition was put on in the early 1900s, extending it to over 300 feet. It is situated between Spring Street and Main Street. The CSX Railroad is currently using the track.

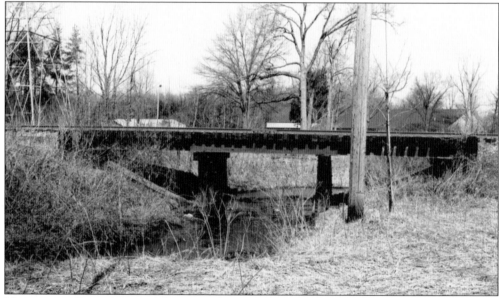

MISHAWAKA RAIL BRIDGE. This 1984 photograph shows the Elkhart and Western Bridge in Mishawaka. The Elkhart and Western Railroad, an 11-mile short line, was the creation of H. E. Bucklen. It opened in 1893 and ran between Elkhart and Mishawaka. At Elkhart it connected with the Lake Shore and Michigan Southern Railroad, crossed over the St. Joseph River, and terminated in Mishawaka where it connected with the Grand Trunk Western Railroad. (Photograph by Jeff Strombeck.)

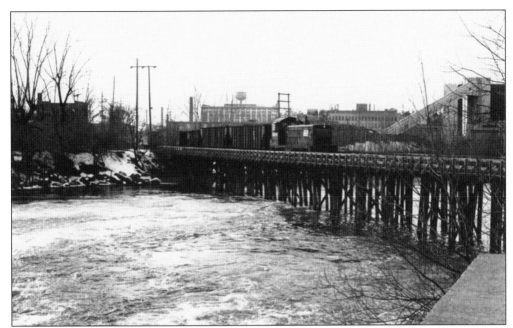

ST. JOSEPH RIVER. This Elkhart and Western trestle no longer exists, but was standing in 1976 as the frigid St. Joseph River flowed menacingly beneath it. Trestle bridges were made of wood and often built quickly so that trains could use them sooner. This photograph was taken in February as Penn Central Railroad diesel No. 8844 pulled a train over the river. (Photograph by Jeff Strombeck.)

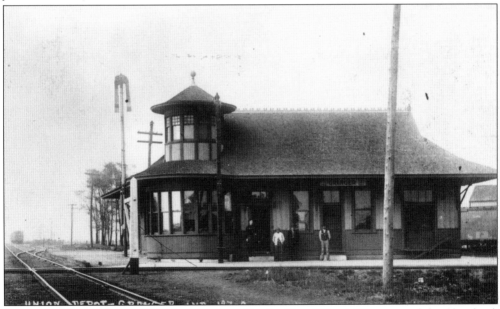

GRANGER UNION DEPOT. This depot was used by the Grand Trunk Western and the Cleveland, Cincinnati, Chicago and St. Louis Railroads. This postcard shows the unique rounded office of the agent and a complementary turret above it. Granger is located only a few miles south of the Michigan state line. The Grand Trunk entered Indiana at Mishawaka, turned west towards South Bend, and then to Valparaiso before proceeding south. (Courtesy of John Strombeck.)

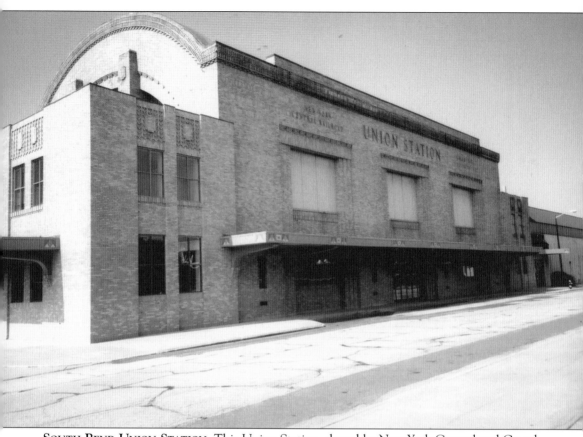

SOUTH BEND UNION STATION. This Union Station, shared by New York Central and Grand Truck Western Railroads, is another of the special stations remaining in northern Indiana. Construction began in 1928, and it opened in 1929, before the Wall Street stockmarket crash. It is a brick station, located on South Street and has 50-foot vaulted ceilings in the waiting area. It was designed by New York architects Alfred Fellheimer and Stewart Wagner, who also designed the Buffalo Central Railroad and Cincinnati Union Railroad terminals. The grand size of the terminal lent itself to the great numbers who passed through it. It has recently been transformed into offices and a banquet hall. The combined restoration efforts of the South Bend Heritage Foundation, the Historic Landmarks Foundation of Indiana, the City of South Bend, and a local entrepreneur have been quite successful.

SOUTH BEND PENNSYLVANIA DEPOT. At the corner of Main and Bronsen Streets is the lengthy Pennsylvania combination depot of South Bend. Built in 1900, the two-story front of the building was used as a passenger depot and the single-story portion was used as a freight house. It is now being used as a clinic. The depot has been altered quite a bit since this photograph was taken in 1962. (Photograph by John Strombeck.)

SOUTH BEND ENGINE HOUSE. This photograph, taken in November 1981, shows the New Jersey, Illinois and Indiana Railroad engine house in South Bend. The Singer Sewing Machine Company once had offices in New Jersey and in South Bend. The New Jersey, Illinois and Indiana Railroad was used mostly in South Bend by the Singer company. (Photograph by Jeff Strombeck.)

BREMEN DEPOT. The passenger depot, located on North Center Street, was built between 1918 and 1930, and is currently vacant. This photograph was taken in the summer of 1981. Historic Bremen, Inc., is in the process of raising funds for the Bremen Depot Restoration Project. This old Baltimore and Ohio Railroad depot will have a place in Bremen's future due the help of a $375,162 gift from a transportation enhancement grant awarded through the Indiana Department of Transportation. This gift will only cover 80 percent of the funds needed. The other 20 percent of the restoration costs will be raised locally. The depot is still owned by CSX Railroad, but the plan is to acquire the depot and move it to another site on the east side of Bremen that is reserved for the depot. The intent is for it to become a Bremen information center and railroading museum. (Photograph by Jeff Strombeck.)

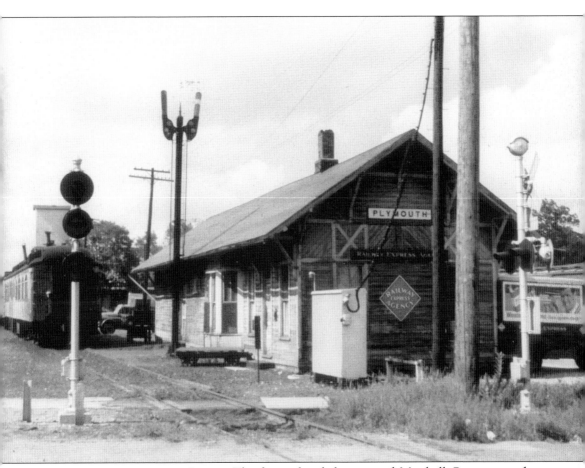

PLYMOUTH COMBINATION DEPOT. The first railroad that entered Marshall County was the Cincinnati, Peru, and Chicago Railroad in 1855. This railroad later merged into the Lake Erie and Western Railroad and then merged into the Nickel Plate Road. This Lake Erie and Western Railroad depot is located on West Garro Street, which is on the west side of Plymouth. It was built in 1889 and was a combination depot. This image shows some passenger coaches to the left and the once-familiar Railroad Express Agency delivery truck to the right. This image was taken in 1963, and by this time, passenger rail service was nearly a thing of the past. By 1971, Amtrak was beginning operation through the federal government's attempt to salvage railway passenger service across America. The delivery and Railroad Express Agency truck seen in this photograph show that freight service was still present, although not necessarily thriving. (Photograph by John Strombeck.)

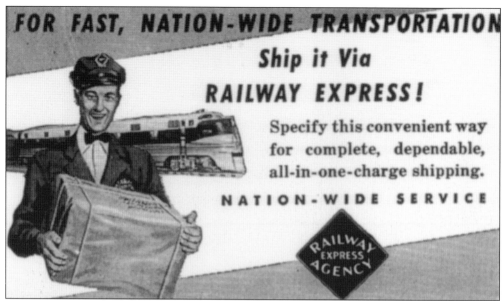

RAILWAY EXPRESS AGENCY. In 1929, the railroads bought out the private owners of the American Railway Express to form the Railway Express Agency. The Railway Express Agency was a company owned by the railroads, but run independently of the railroads. This advertisement promoted the convenience and dependability of the Railway Express Agency. The company transported small, valuable packages expediently and responsibly with their green train cars and green trucks with the red diamond emblem. (Courtesy of MRHTS.)

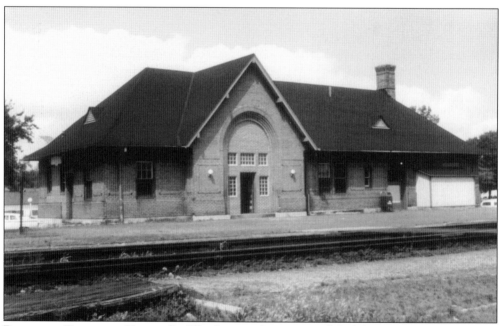

PLYMOUTH PASSENGER DEPOT. On West Laporte Street one will find this Pennsylvania Railroad passenger depot. This brick building was constructed in 1914 and has an arched entrance. CSX Railroad is now using this trackage. The depot is currently being used for railroad maintenance. The trackside photograph was taken in 1963. (Photograph by John Strombeck.)

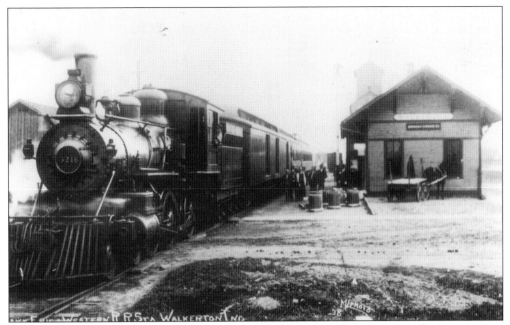

WALKERTON DEPOT. The Walkerton Lake Erie and Western wood combination depot was built in 1891. This image shows a northbound passenger train pulled by steam engine No. 5216 and a crowd gathering at the depot. A horse-drawn wagon is on the right. This locomotive was originally built for the Lake Shore and Michigan Southern Railroad. (Courtesy of Robert Albert.)

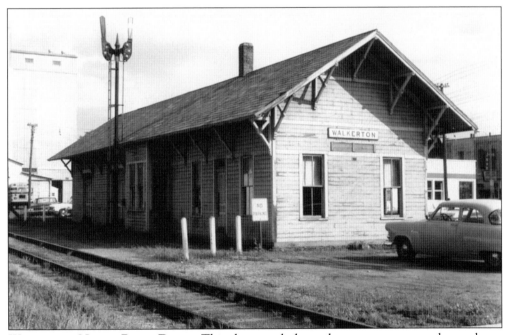

WALKERTON NICKEL PLATE DEPOT. This photograph shows the same structure as shown above, only several years later. The steam locomotive would now be a diesel. When this photograph was taken in 1962, it was still a Lake Erie and Western depot, but it changed to Nickel Plate Road ownership within a couple of years. (Photograph by John Strombeck.)

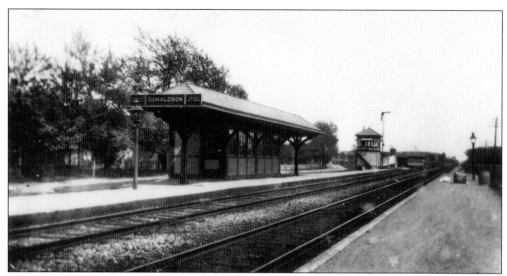

DONALDSON SHELTER. Donaldson is located between Hamlet and Plymouth in Marshall County. This postcard print shows a waiting station that was torn down long ago. It also shows a double track, which gives some significance to the area as a railroad stop. A small amount of freight can be seen on the opposite side of the shelter platform. (Courtesy of Robert Albert.)

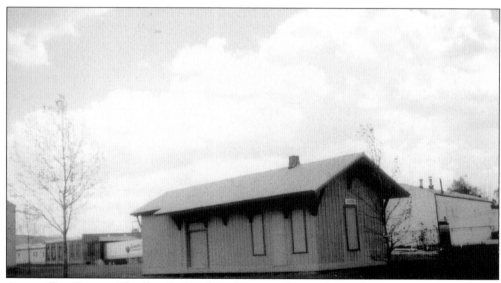

AKRON ERIE DEPOT. This Erie Railroad combination depot is located on Front Street in Akron. It was constructed in 1883 of wood with board-and-batten siding. The Erie Railroad merged in 1960 with the Delaware, Lackawanna and Western to become the Erie-Lackawanna Railroad. This merger led to it being assigned to become part of Conrail in 1976.

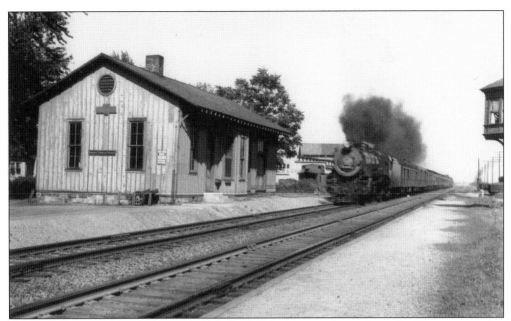

BOURBON PENNSYLVANIA DEPOT. The town of Bourbon is located south of Bremen, on the Pennsylvania Railroad line. The photograph shows a steam locomotive puffing black smoke as it comes into the depot. Bourbon's first actual depot was built around 1872. After this structure burned in 1883, interim quarters were used until a new depot was built later that year. Today Bourbon does not have a depot. (Photograph by Robert Schell, courtesy of John Strombeck.)

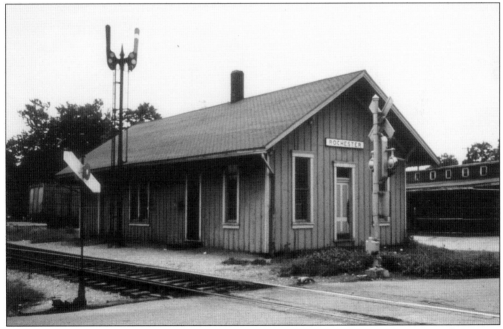

ROCHESTER DEPOT. The Fulton Historical Society has converted this Lake Erie and Western Railroad passenger depot into a museum. This is a wood structure and was built by the Indianapolis, Peru, and Chicago Railroad in 1877. Today it is located at Lakeview Park and can be seen from U.S. Highway 31, just north of Rochester. (Photograph by John Strombeck.)

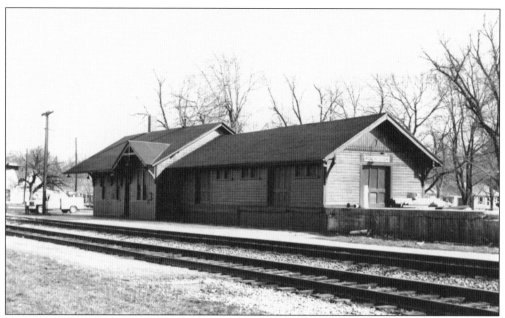

ROCHESTER ERIE-LACKAWANNA DEPOT. This Erie-Lackawanna Railroad combination depot was built in 1892 of frame design with both vertical and horizontal siding. The depot's length was increased several years ago by extending the freight house portion. It is located on West First and Pontiac Streets in Rochester. The freight dock is to the right of the passenger depot. This trackside photograph was taken in 1974. (Photograph by Jeff Strombeck.)

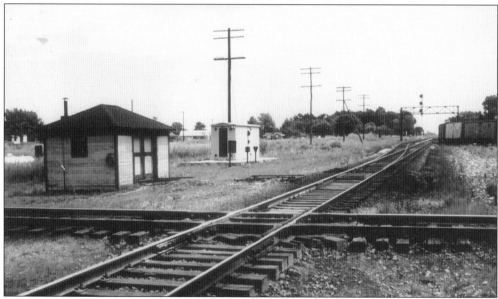

ROCHESTER DIAMOND. This photograph shows the rare absence of a depot at a railroad line diamond. The components of this junction were the Erie-Lackawanna Railroad and the Nickel Plate Road. The Erie-Lackawanna Railroad ran east to west connecting Huntington and North Judson. The Fulton County Railroad operated in the 1980s, serving the grain elevators of this region. Now CSX Railroad serves much of Fulton County. This image was captured in 1963. (Photograph by John Strombeck.)

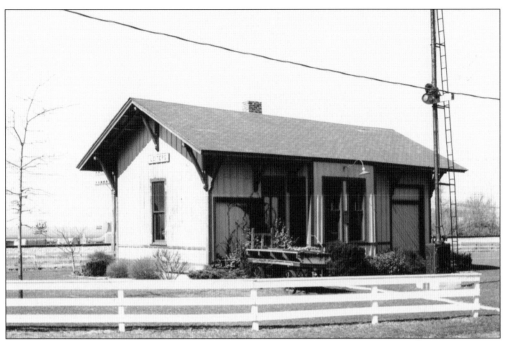

LEITERS FORD. Leiters Ford is one of several railroad towns in Fulton County. This depot is a museum today and is part of the Fulton County Historical Society's effort to preserve railroad heritage in that community. The depot was built in 1883 of a board-and-batten exterior. This photograph was taken in 1974. (Photograph by Jeff Strombeck.)

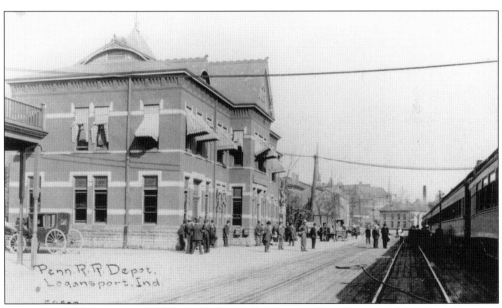

LOGANSPORT PENNSYLVANIA DEPOT. Railroads first came to Cass County in 1855 with the arrival of the New Castle and Richmond Railroad. Logansport's rich rail history included it being the home of a Pennsylvania Railroad main repair shop. Early in the 1900s, there were as many as 3,000 people employed by the railroad in Logansport. This print of a postcard shows the now demolished two-story Pennsylvania Railroad depot in Logansport. (Courtesy of John Strombeck.)

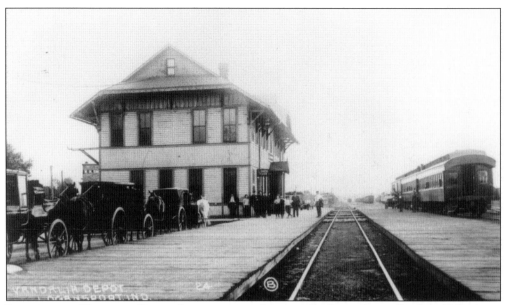

LOGANSPORT VANDALIA DEPOT. Logansport was home to the Pennsylvania Panhandle Railway, the Wabash, and the Vandalia Railroad lines. This photographic postcard shows the Vandalia depot that has been demolished. The image shows the passenger platforms and the carriages lined up waiting for the next train. Across the track is either a passenger coach or an interurban train. (Courtesy of John Strombeck.)

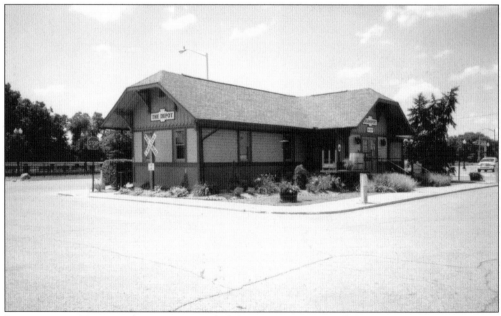

LOGANSPORT TODAY. There is not much left in Logansport to help recall its strong railroad heritage. This structure may appear to be a depot, but was actually once the Pennsylvania Railroad yard office. It was donated to the local chamber of commerce and moved in 1982 to the corner of Melbourne and South Fourth Streets, near the Wabash River. It is now a museum and tourist center.

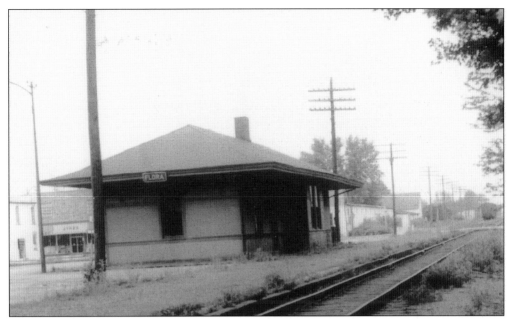

FLORA COMBINATION DEPOT. This Vandalia combination depot in Flora was of a similar plan to the Vandalia depot in Grass Creek. It is a wood-frame structure and today is located on South Sycamore Street, which is also Indiana Route 75. Today many of the windows are covered with plywood and the building does not resemble a depot. It was built in 1908. (Photograph by Ron Stuckey, courtesy of John Fuller.)

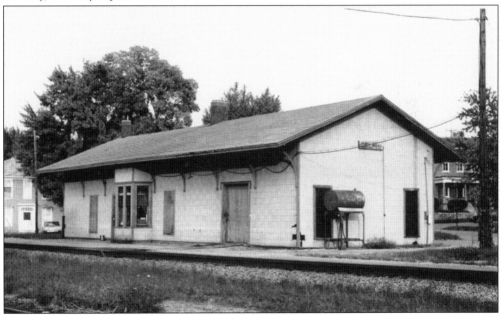

DELPHI WABASH DEPOT. This 1975 photograph shows the Delphi Wabash depot that once stood at 208 North Market Street. It was built in 1885 and, according to insurance maps, the structure was first a Wabash, St. Louis and Pacific Railroad depot. The Fort Wayne and Wabash Valley Traction Company interurban depot is the only remaining depot in Delphi. (Photograph by Jeff Strombeck.)

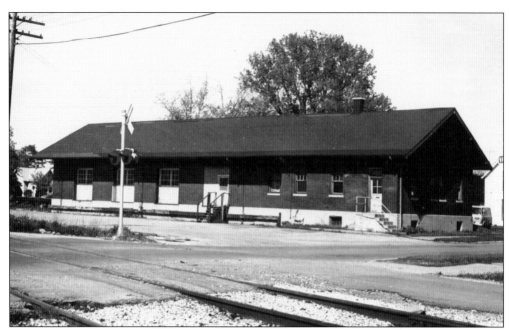

FRANKFORT PENNSYLVANIA FREIGHT HOUSE. This Pennsylvania freight house was built between 1916 and 1927 according to Sanborn insurance maps. During its existence it was also used for some time as a passenger depot. It is a brick structure located at 510 West Morrison Street in Frankfort. It is now being used as a lumber company office. (Photograph by Jeff Strombeck.)

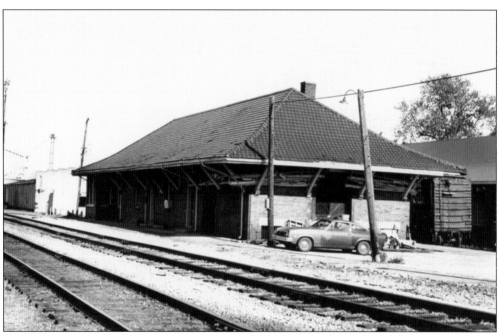

FRANKFORT NICKEL PLATE DEPOT. This Nickel Plate Road passenger depot is located at 260 Bunnell Street and was constructed in 1914. Frankfort also had a Nickel Plate freight depot that was demolished in the 1980s. This passenger depot was made of brick and is now used by a business. This photograph was taken in 1981. (Photograph by Jeff Strombeck.)

FRANKFORT INTERURBAN DEPOT. In 1911, the Kokomo, Frankfort, and Western Traction Company interurban was formed. On Main Street at Morrison Street in Frankfort is a Kokomo, Frankfort, and Western passenger storefront depot that was built in 1912. It opened a 26-mile line between Kokomo and Frankfurt in 1912. Eventually it merged into the Northern Indiana Power Company in 1922. The interurban line was abandoned around 1932.

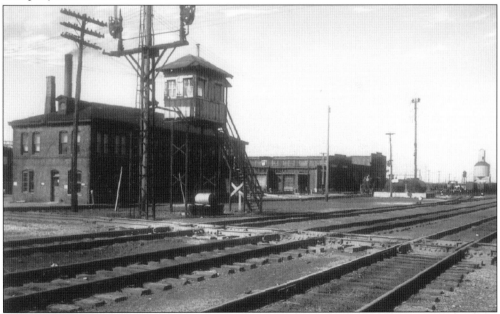

FRANKFORT NICKEL PLATE YARD. This photograph shows, from left to right, the two-story freight depot, the roundhouse, the locomotive repair shop, and the coaling tower on the far right. Sometime after 1976 the freight depot was demolished. This photograph also shows the junction diamond of the Nickel Plate and the Monon Railroads and the tower in front of the freight house. (Photograph by Ron Stuckey, courtesy of John Fuller.)

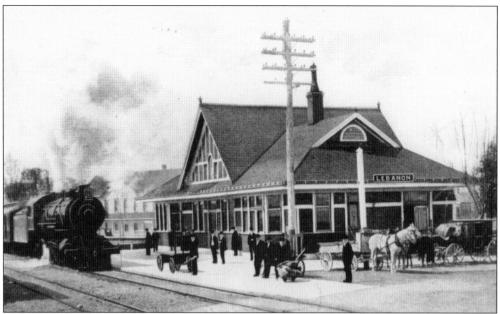

LEBANON DEPOT. This postcard print shows the arrival of a steam locomotive at the Lebanon Depot. This depot was operated by the Cleveland, Cincinnati, Chicago and St. Louis Railroad. Several workers are in place and ready to remove freight and baggage after the locomotive stops. The depot's many windows were to allow the operator to visually spot the train and inspect it for problems. (Courtesy of the Hoosier Valley Railroad Museum.)

LEBANON PENNSYLVANIA DEPOT. The Pennsylvania Railroad depot in Lebanon was built in 1918 and is now used for offices. It is a passenger station with arched doors and windows. The station has had many alterations, such as bricking-in part of the arched windows. It is located on South Smith Street and has a hip roof with a cupola.

Three

NORTHWESTERN INDIANA

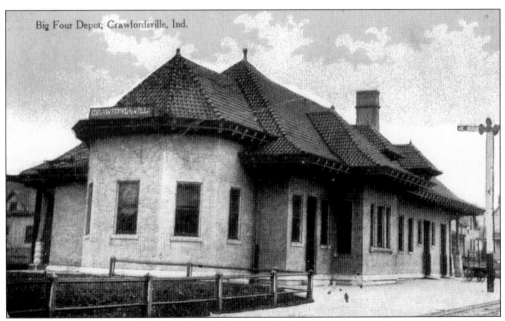

Big Four Depot, Crawfordsville, Ind.

CRAWFORDSVILLE BIG FOUR. This postcard shows the Big Four depot in Crawfordsville. The Big Four was an abbreviated reference to the Cleveland, Cincinnati, Chicago and St. Louis Railroad. This depot was torn down over 25 years ago, but was once very vital to the rail transportation in Crawfordsville. The structure looks to have had a stucco-like exterior. The postcard carries a 1912 postmark. This postcard has no manufacturer's name.

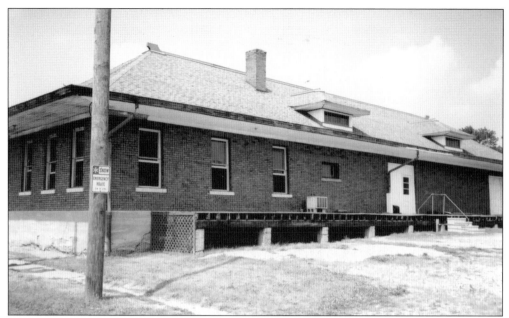

CRAWFORDSVILLE FREIGHT HOUSE. This Peoria and Eastern Railroad brick freight house was built in 1912. It is located at 512 Wallace Avenue in Crawfordsville. Probably the greatest fame of the Peoria and Eastern Railroad is that it annually ran a commuter train to Indianapolis to serve the race fans of the Memorial Day 500-mile race. The depot is now being used by a business as a storage area.

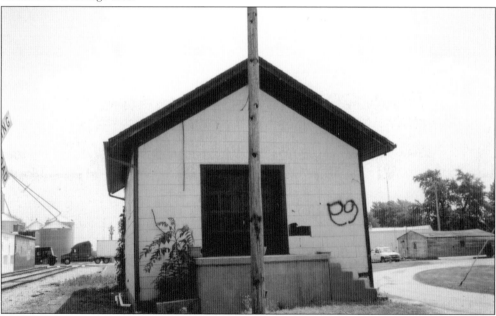

WOLCOTT FREIGHT HOUSE. This Pittsburgh, Cincinnati, Chicago, and St. Louis Railroad freight house is a simple wood-frame depot with board-and-batten siding. It is now located on South Second Street in Wolcott and was moved from its original building site in the early 1900s. It was built in 1873 by the Toledo, Peoria, and Burlington Railroad. It is believed to have first been a combination depot, but portions of the passenger depot were removed around 1929.

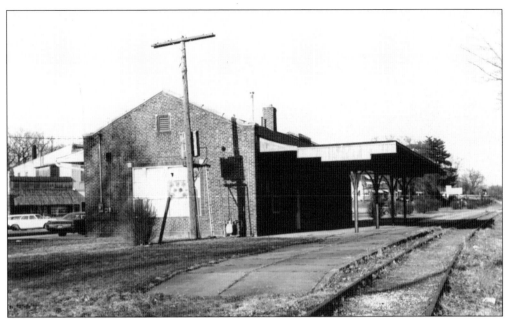

CULVER PENNSYLVANIA DEPOT. The Culver depot is believed to have been built in 1925 by the Pennsylvania Railroad and is situated near Lake Maxinkuckee. Years ago, riding the train to Culver was quite popular with people from neighboring communities such as South Bend. They would spend their weekends in Culver. This photograph, taken in 1974, shows the depot that currently exists. The depot has been recently restored. (Photograph by Jeff Strombeck.)

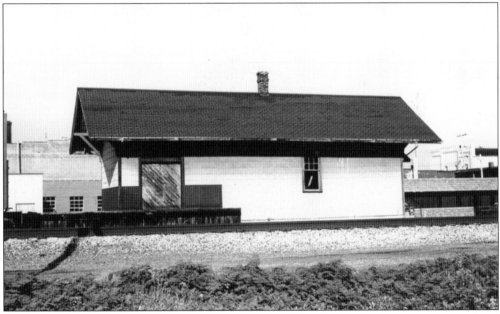

WINAMAC FREIGHT DEPOT. This Pittsburgh, Cincinnati, Chicago, and St. Louis Railroad freight house has a construction date of 1862, making it one of the oldest railroad buildings in the state. The depot is found on Logan Street in Winamac and was built by the Chicago and Great Eastern Railway. This photograph was taken in 1981. It has since been restored and is a point of pride for the community. (Photograph by Jeff Strombeck.)

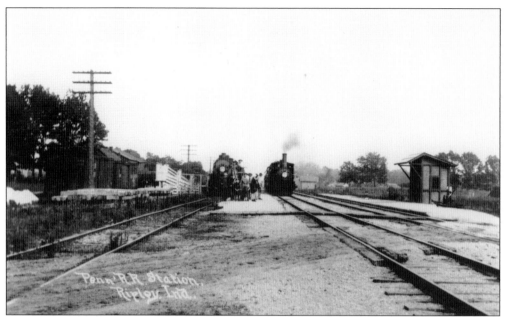

RIPLEY PENNSYLVANIA DEPOT. Ripley is located on the Pennsylvania rail line between Winamac and North Judson. This photograph shows busier times in Ripley with several passengers waiting for the train. Also shown are cars on the track, stock chutes, and a waiting shelter to the right. Today there is little evidence of Ripley's railroad heritage as everything is gone, including the tracks. (Courtesy of Robert Albert.)

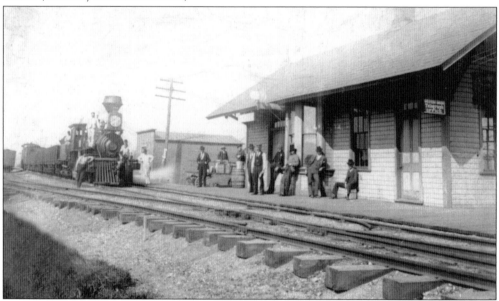

STEAM LOCOMOTIVE APPROACHING KNOX DEPOT. This photograph, taken in 1895, shows Nickel Plate Road steam locomotive No. 44 pulling into the Knox Depot. Persons in the photograph, not in order, include Frank Fox, ticket agent; William Fox, telegraph operator; Charles H. Bromelmeur, engineer; J. H. Rainey, fireman; John McVey, conductor; and Ralph Springer, brakeman. Other names were not legible. This Nickel Plate depot was established in 1882 and was in use until 1984. (Courtesy of the Starke County Historical Society.)

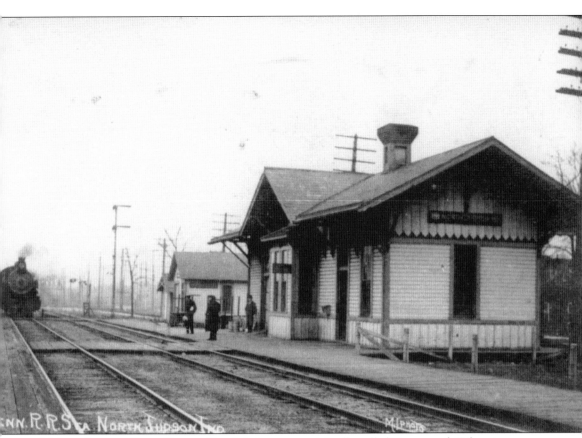

NORTH JUDSON PENN DEPOT. North Judson was originally called Brantwood. When its name was changed to North Judson, it was named after one of the promoters of the Chicago and Great Eastern Railway Company. By 1868, the Chicago and Great Eastern and other railroads had built lines to connect numerous northern Indiana cities from Union City, Ohio, to Chicago. North Judson's railroad heritage lies with at least four major railroads. These include: the Pennsylvania Railroad, the New York Central Railroad, the Erie Railroad, and the Chesapeake and Ohio Railway. In this postcard print the train is heading toward the south. First known as the Cincinnati and Chicago Railroad, a depot had been established there around 1861. This depot was demolished prior to 1985. The Hoosier Valley Railroad Museum, located at North Judson, has recently built a depot to use for their museum and for the ticket sales for their excursion railroad. The Hoosier Valley Railroad Museum also sells railroad-related items in the gift shop. (Courtesy of Jim Shilling.)

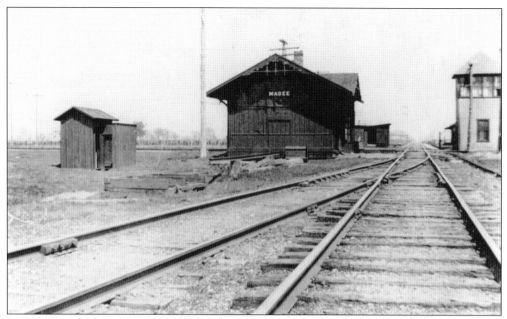

MAGEE JUNCTION. Magee is southwest of LaPorte at the juncture of the Pere Marquette and Wabash Railroads. Magee was a very small town and was fortunate to have a large depot, as there may not have been enough business to justify it. Hoosier Valley Railroad Museum vice-president Elmer Mannen was an operator at Magee in the 1950s. The photograph was taken on May 19, 1921. (Courtesy of Robert Albert.)

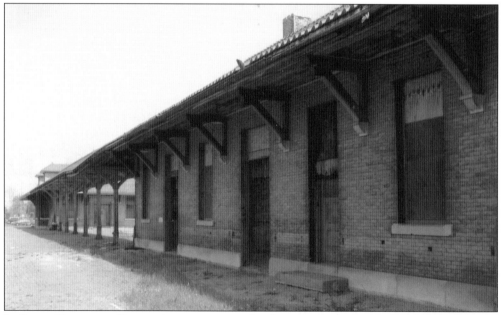

LAPORTE PASSENGER DEPOT. A very impressive brick passenger depot stands at 803 Washington Street in LaPorte. This Lake Shore and Michigan Southern Railroad depot was constructed in 1909 and has a red-tiled roof. It is located within the LaPorte Historic District. It has a long canopy between the depot and the express building. The Lake Shore and Michigan Southern Railroad merged into the New York Central Railroad in 1915.

70

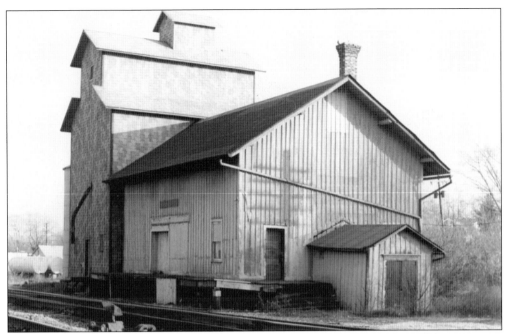

NEW CARLISLE FREIGHT DEPOT. New Carlisle is located in the northern part of the state, west of South Bend and near Hudson Lake. New Carlisle was once a stop on the South Shore Line. The New York Central Railroad operated the freight depot shown in this 1973 photograph. It must have been a busy rail area to require double tracking. (Courtesy of Jeff Strombeck.)

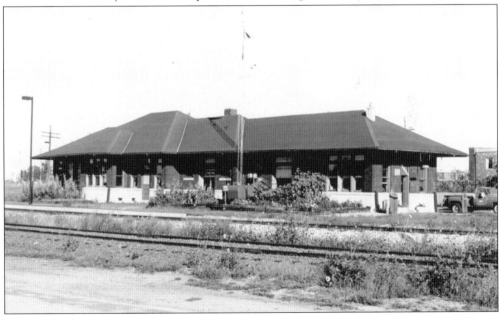

MICHIGAN CITY PASSENGER DEPOT. The Michigan Southern and the Northern Indiana Railroads merged in 1855. These were predecessors of the giant New York Central Railroad. The passenger depot in this 1981 photograph was operated by the New York Central Railroad. Many rail structures in Michigan City were located near Lake Michigan. (Photograph by Jeff Strombeck.)

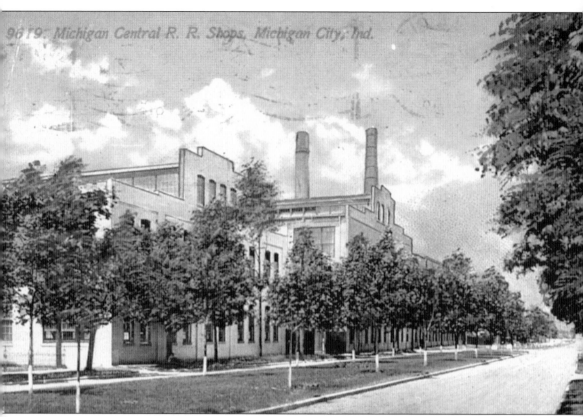

HASKEL AND BARKER CAR COMPANY. The Haskell and Barker Car Company, manufacturers of railroad cars, was established in 1852 and became Michigan City's largest employer and a huge player in the growth and success of the city. By the 1900s, they were the leading rail car producer in the United States and the complex had 34 buildings on 116 acres. In 1922, it became part of the Pullman Car Company. The factory is credited with being the birthplace of the first modern assembly line, a first often credited to Henry Ford. In July 1973, a torch crew that was doing work for a new tenant had left a hot bolt smoldering unnoticed. By 11:00 p.m. smoke was seen coming from the complex. The raging inferno destroyed many structures, but would spare the office building, the machine shop, and a warehouse at the north end of the property. (Produced by Acmegraph Company.)

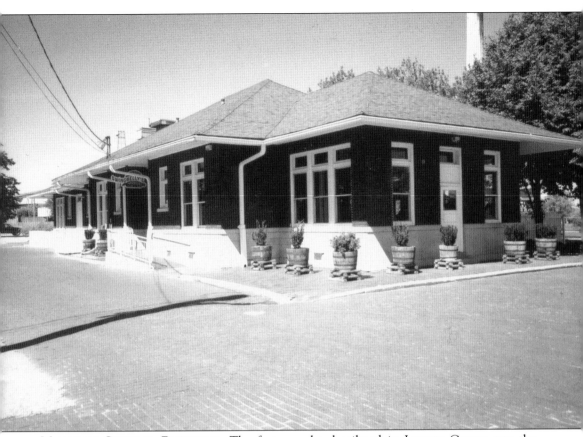

MICHIGAN CENTRAL PASSENGER. The first completed railroad in Laporte County was the Michigan Central Railroad trackage that was finished in 1850. The Michigan Central Railroad brick passenger depot is located on Washington Street in Michigan City. It was constructed in 1914 for the Chicago to Detroit passenger service. It is one of the only depots remaining in Michigan City other than the Chicago, South Shore and South Bend Railroad (South Shore Line) shelters and train works facility. The railroad depot is a reminder of how valuable the transportation industry was in the development of Michigan City. The Amtrak train still stops here, with a shelter to the right of the depot in this photograph. The depot is a prairie-style building with overhanging eaves to shelter passengers in all kinds of weather. Swingbelly's Restaurant was recently housed in the depot.

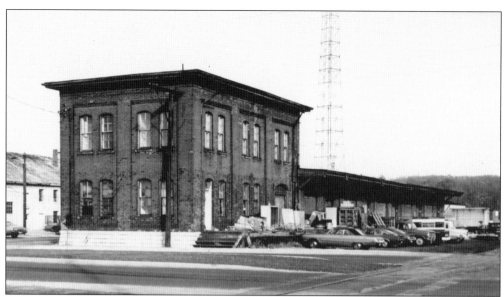

MICHIGAN CITY FREIGHT HOUSE. Prior to the 1968 merger between the New York Central Railroad and the Pennsylvania Railroad, this freight house was operated by the New York Central Railroad. The merger was short-lived, only lasting about eight years. This photograph was taken in 1973 and shows the New York Central Railroad loading dock, several vehicles, and some trailers. The office portion of the depot was two-stories and the single story was where freight was unloaded. (Photograph by Jeff Strombeck.)

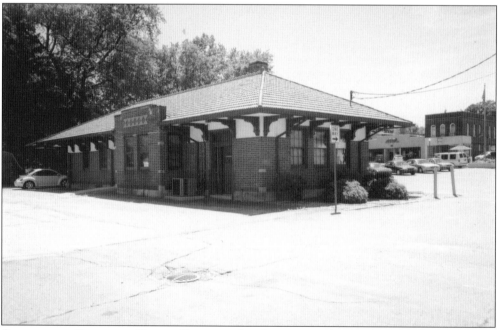

CHESTERTON PASSENGER DEPOT. Chesterton has done a nice job in finding uses for their retired railroad structures. This New York Central Railroad passenger depot is now being used by the city. It is located at 202 Broadway Street, and it was built in 1914. It has a brick and stucco exterior. The tracks are in use by CSX Railroad.

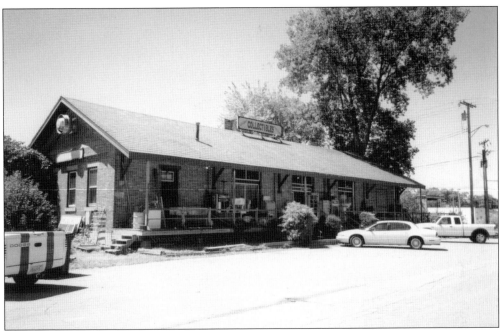

CHESTERTON FREIGHT HOUSE. Only a block from the passenger depot is the New York Central Railroad freight house. It is located on the corner of Broadway and Fourth Streets in Chesterton. It was constructed of brick in 1914, and in 2004, was being used as a collectibles shop. The tracks are in use by CSX Railroad.

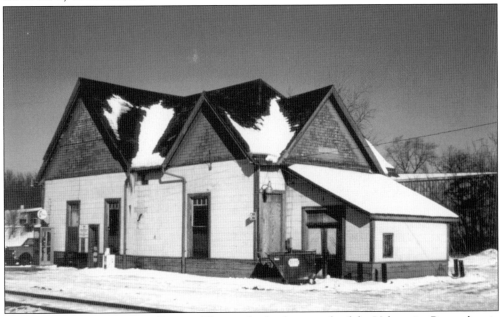

VALPARAISO PENNSYLVANIA DEPOT. This trackside photograph of the Valparaiso Pennsylvania Railroad depot was taken in January 1981, and shows a snowy scene, reflective of northern Indiana's winters. The official address of the Pennsylvania Railroad depot was 453 West Lincoln Way. This Pennsylvania Railroad depot is no longer standing as it was torn down after a fire. (Photograph by Jeff Strombeck.)

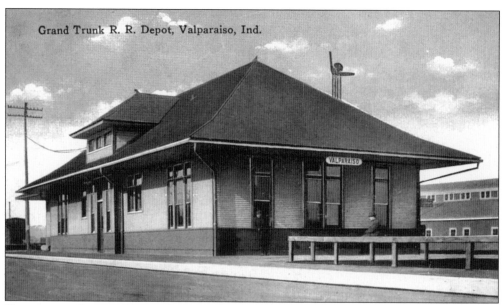

Grand Trunk R. R. Depot, Valparaiso, Ind.

VALPARAISO GRAND TRUNK DEPOT. The Grand Trunk Western Railroad rail line entered Indiana north of Mishawaka and then went to South Bend and Valparaiso. This postcard shows the Grand Trunk Western Railroad wooden passenger depot that is located at the intersection of Bush Street at 801 Calumet Avenue in Valparaiso. The trackage today is used by the Canadian National Railroad. The Grand Trunk Western Railroad station seems to be mainly used for storage today. This postcard has no manufacturer's name.

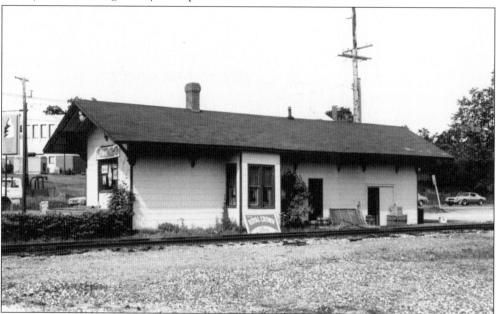

HEBRON PASSENGER DEPOT. As early as 1883, the Pennsylvania Railroad operated a train between Hebron and Chicago. In 1909, the Hebron train stop was discontinued. The wooden Hebron Pennsylvania Railroad passenger depot was built in 1867 by the Chicago and Great Eastern Railway. It has been relocated from Bates and Main Streets to Mussman Trail and now serves as a museum. This photograph was taken in 1981. (Photograph by Jeff Strombeck.)

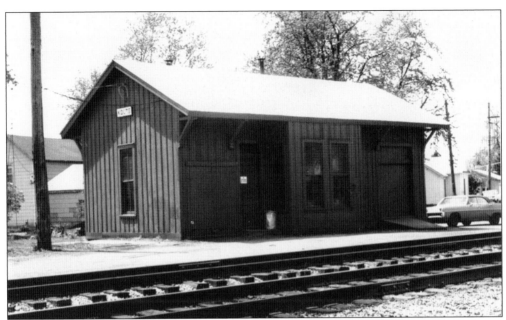

KOUTS PENNSYLVANIA DEPOT. Kouts is a small town east of Hebron. It is home to the Pennsylvania Railroad depot seen in this photograph. Kouts was the site of a Chicago and Atlantic Railway rear-end train wreck in October 1887, a collision that resulted in nine fatalities. It is now a snack shop on State Road 49. It was built of wood-frame construction in 1907. (Photograph by Jeff Strombeck.)

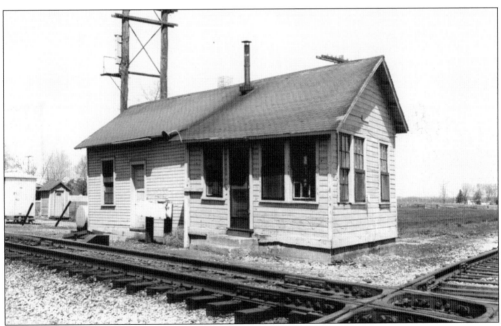

SOUTH WANATAH NICKEL PLATE ROAD DEPOT. This frame Nickel Plate Road depot was located at the juncture of where the Nickel Plate and the Monon Railroad crossed. The Nickel Plate was an east to west track and the Monon line traveled north to Michigan City. South Wanatah was one of many towns located on the rail line and not located near main roads. Other railroad structures can be seen to the left of the depot. (Photograph by Jeff Strombeck.)

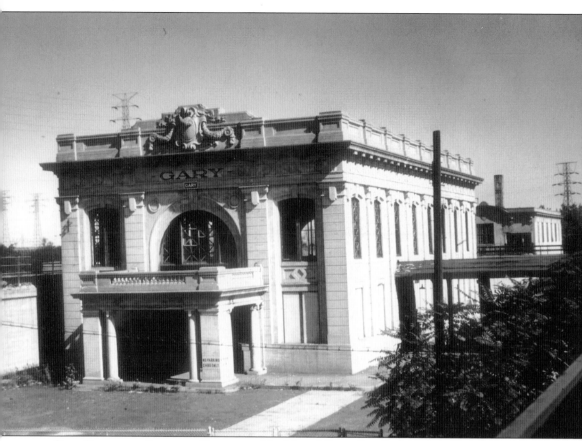

GARY PASSENGER STATION. Gary, named for United States Steel's chairman E. H. Gary, became a huge industrial center when it was determined that steel was going to be produced there. Gary was a good choice for this industry because it had access to a major waterway and access to several rail lines. Lake Michigan provided the waterway and there were many railroads moving to and from Chicago that were close enough to meet the need of transporting raw materials. This photograph shows the Gary Depot that was built in 1910 between the Lake Shore and Michigan Southern Railroad and the Baltimore and Ohio Railroad's elevated tracks. Both railroads shared this depot. It is currently on Indiana's list of endangered buildings and structures. Today it is in very poor condition, and is just a shell. It is located at the corner of Broadway and Third Streets south of the steel mills. This print was made from a postcard. (Courtesy of John Strombeck.)

GRIFFITH GRAND TRUNK WESTERN. Griffith has a history that reflects its active role in railroading. Five different railroads intersected at Griffith and as many as 180 trains used to pass through the city daily. This Grand Trunk Western Railroad combination depot is located at 201 South Broad Street. It was built in 1911 and has been relocated and restored. It is the home of the Griffith Historical Park and Depot Museum.

HOBART PENNSYLVANIA RAILROAD STATION. This Pennsylvania Railroad passenger depot is located at 1001 Lillian Street in Hobart. It is a brick building that was constructed in 1912. It has been recently restored under the guidance of the Hobart Historical Society. The Hobart Historical Society was instrumental in placing the depot on the National Register of Historic Places.

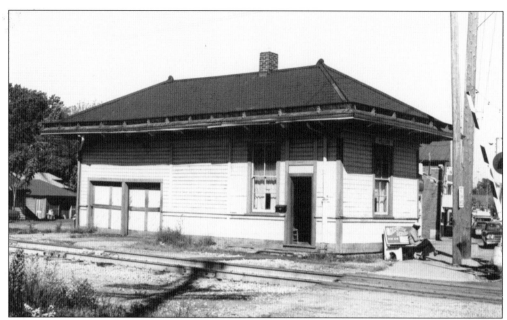

MILLER BALTIMORE AND OHIO DEPOT. This wood frame combination Baltimore and Ohio Railroad depot was built in 1910 in Miller and has horizontal siding. This trackside photograph was taken in 1975 and shows its simple construction. It is located on Lake Street just north of the current CSX Railroad tracks and near the South Shore Line tracks. It was being used to house a pizza restaurant in 2004. (Photograph by Jeff Strombeck.)

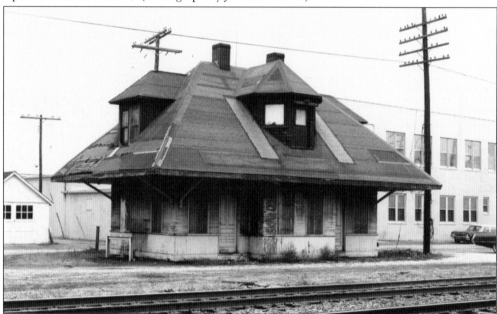

HAMMOND BALTIMORE AND OHIO. The Baltimore and Ohio Railroad was built in Hammond in 1874. This trackside photograph shows one of their depots as it looked in 1976. Hammond was a major city with more than 115 industries and the need for many railroads. Some of the other railroads serving Hammond included the Pennsylvania, the Monon, the Chesapeake and Ohio, the South Shore Line, and the Indiana Harbor Belt. (Photograph by John Strombeck.)

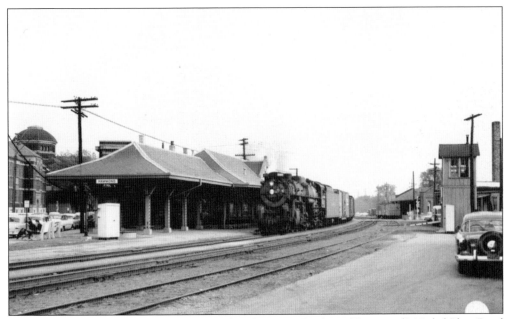

HAMMOND NICKEL PLATE. This photograph, taken in 1950, shows Hammond's Nickel Plate Road depot with Nickel Plate steam locomotive No. 767 in the front. It was built between 1900 and 1916, replacing an earlier frame depot. After the railroad stopped using the depot, it was leased to a company that was storing tires in it when it burned. The depot has since been torn down. (Photograph by Harry Zillmer, courtesy of John Strombeck.)

GOODLAND PENNSYLVANIA DEPOT. This Pittsburgh, Cincinnati, Chicago, and St. Louis Railroad depot was built in 1871 by the Toledo, Peoria, and Western Railroad and has a frame construction with exterior shingle siding. The contemporary Toledo, Peoria, and Western Railroad, now a shot line, currently uses the trackage, which extends from Fort Madison, Iowa, to Logansport.

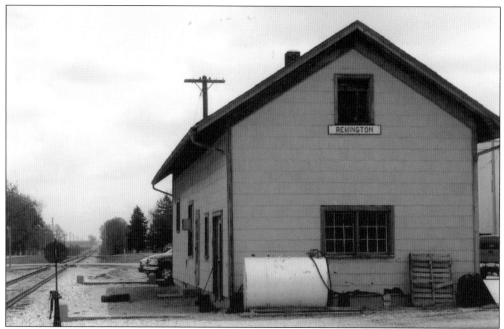

REMINGTON PENNSYLVANIA DEPOT. This Pittsburgh, Cleveland, Cincinnati, and St. Louis Railroad combination depot is a basic frame building with shingle siding. It is located on South Railroad Street in Remington. It was built by the Toledo, Peoria, and Burlington Railroad in 1868, making it one of the state's oldest depots. This trackside photograph was taken in 2006.

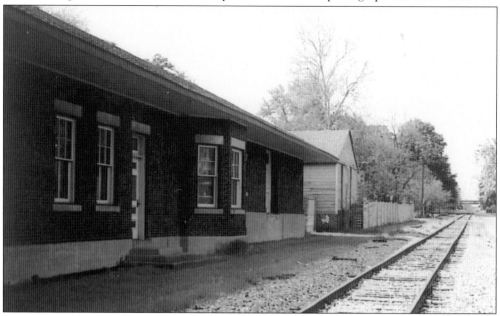

ATTICA COMBINATION DEPOT. A Chicago and Eastern Illinois Railroad combination depot stands at the corner of South Union and West Washington Streets in Attica. It was built in 1912 and was later used by the Chicago, Attica, and Southern Railroad as a headquarters. It was being used by a lumber company in 2004. The brick building has an addition on the north end. This trackside photograph shows the operator's bay window.

Four

INDIANA'S
MONON RAILROAD

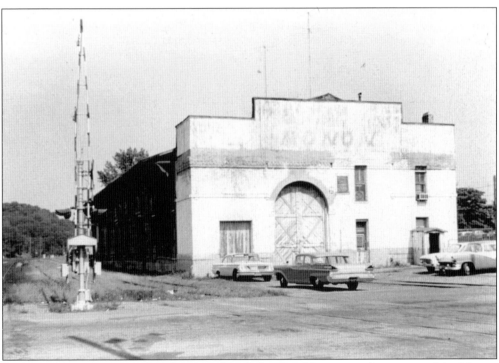

MICHIGAN CITY DEPOT. This chapter will include a brief discussion about some of the Monon depots that have now been demolished and those that still remain, from Michigan City and south toward Indianapolis. Michigan City is where the New Albany and Salem Railroad's first president, James Brooks, intended to terminate the railroad. This image, taken in 1962, shows the Michigan City freight house. (Photograph by John Strombeck.)

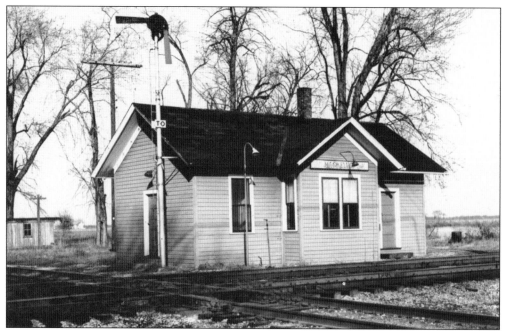

HASKELLS PASSENGER. This junction depot was located at the diamond of the Monon and Grand Trunk Western Railroads. This photograph was taken in 1973. The front of the depot was on the Grand Trunk Western rail line. It was a small wood-frame building with a bay window. (Photograph by Jeff Strombeck.)

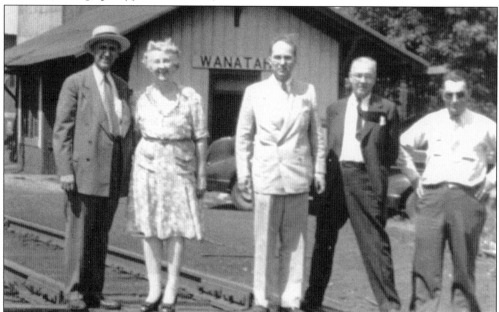

MONON PRESIDENT JOHN BARRIGER. The man in the white suit is Monon Railroad president John Barriger. The photograph was taken at the Monon and Pennsylvania Railroads' diamond at Wanatah depot. John Barriger's exhibition train had stopped there during the July 1947 Monon Railroad Centennial Celebration train tour. It took Barriger's entourage four days and 20 stops to travel from Michigan City to New Albany. (Courtesy of MRHTS.)

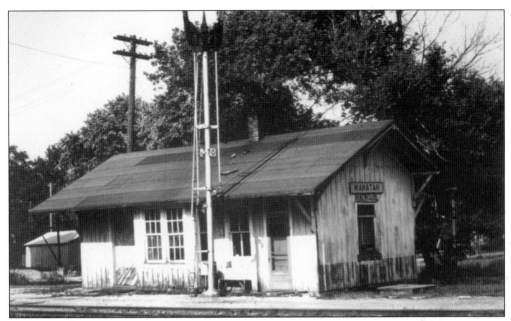

WANATAH DEPOT. This is another photograph of the Wanatah combination depot. It was taken in 1973. The depot's location was on the northeast side of the crossing with the Pennsylvania Railroad track. The crossing diamond is not visible in this photograph, but it was located to the right. The frame wooden depot was torn down sometime after 1976. (Photograph by John Strombeck.)

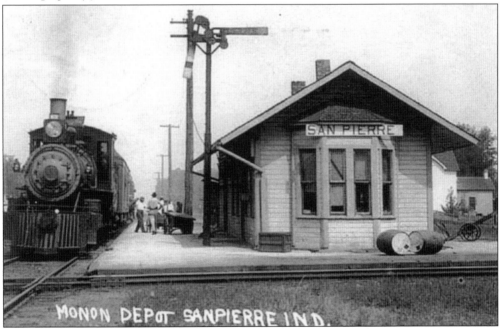

EARLY SAN PIERRE DEPOT. This print was made from a postcard with a 1911 postmark. Its view looks north toward Michigan City. The Monon Railroad had established a stop and built a depot in San Pierre sometime around 1853. The east and west track crossing the Monon track belonged to the Indiana, Illinois, and Iowa Railroad. (Courtesy of Edna M. Stonecipher.)

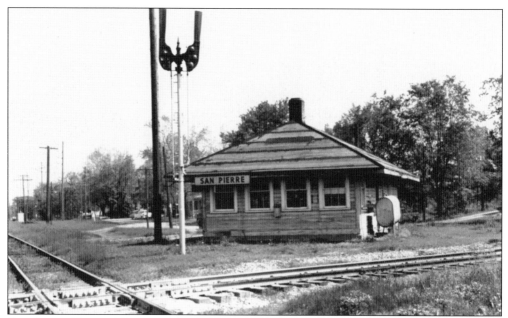

SAN PIERRE DEPOT. This more recent depot at San Pierre was photographed in 1963. It seems to be located on the same property as the San Pierre depot mentioned on the previous page. This depot was uniquely built at a 45-degree angle to the diamond. The diamond of the New York Central and Monon Railroads is seen in the forefront. The depot was demolished before 1977. (Photograph by John Strombeck.)

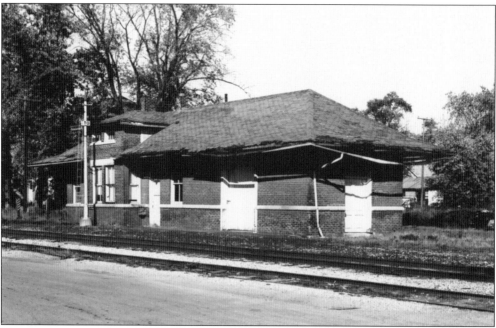

MEDARYVILLE DEPOT. The Medaryville depot was built in 1907 and stood between Main Street and Ridge Street. The town was named after Ohio governor Joseph Medary. Medaryville was one of only a few towns that did not have direct service to Chicago by eastern railroads. This photograph was taken in 1973. The depot has been torn down since 1974. (Photograph by Jeff Strombeck.)

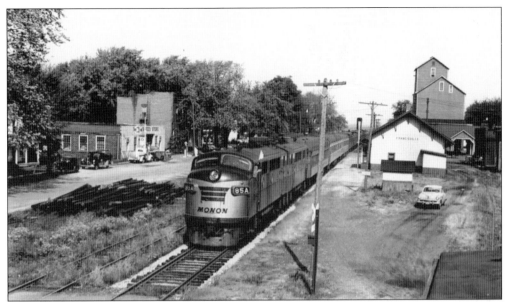

FRANCESVILLE DEPOT. Francesville was named for the daughter of New Albany and Salem Railroad president James Brooks. The young railroad was the reason that Francesville was plotted in 1852. In later years, the depot was shortened and a bay window was also added. The building was razed in 1978. In this October 1949 photograph, the Monon F-3 diesel No. 85A was southbound with the Notre Dame Football team. (Photograph by Harry Zillmer, courtesy of John Strombeck.)

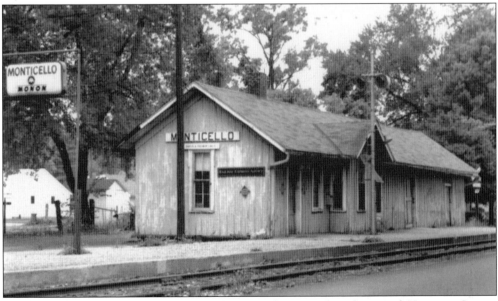

MONTICELLO DEPOT. The Monticello depot sat between Broadway and Harrison Streets on the east side of the tracks. The bridge that once carried the Monon Railroad over the Tippecanoe River in Monticello is now gone. It was torn down before 1993. In the late 1950s, the RCA Company was the Monon's leading customer, shipping and receiving over 1,000 cars of materials and product. The depot was demolished after 1974. (Photograph by Dick Fontaine.)

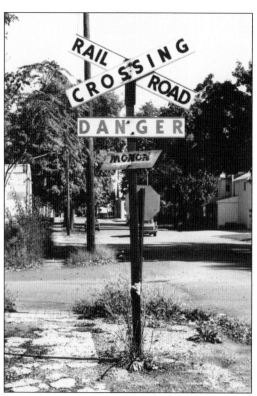

MONTICELLO CROSSING SIGN. The significance of this railroad crossing sign is the small sign below the Danger sign. It designates the crossing as a Monon Railroad track and crossing. Not all companies placed that distinction on their signs. The Monon Railroad was a point of pride for many Hoosiers as it was the only railroad that was entirely within the borders of Indiana. This photograph was taken in 1973. (Photograph by Jeff Strombeck.)

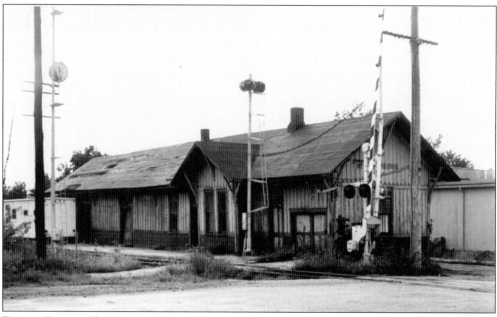

DELPHI DEPOT. The Monon Railroad was built through Delphi between 1879 and 1881. Several Delphi businessmen had enough influence, business savvy, and foresight to know that having a railroad passing through their city would be lucrative. Eventually the Indianapolis, Delphi, and Chicago Railway was built. This photograph of the Delphi depot was taken in 1975. It has since been torn down. (Photograph by Jeff Strombeck.)

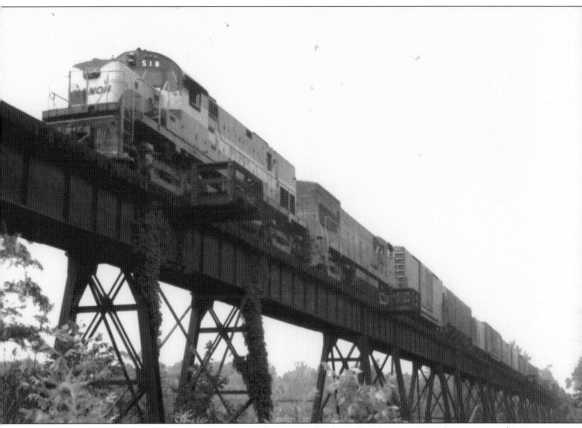

WILDCAT CREEK BRIDGE. A combination depot was built in Owasco in 1885 for just over $900. The Owasco depot was razed several years ago. This photograph was taken along the Monon Railroad line near Owasco, which is north of Rossville, on the Michigan City to Indianapolis line. The Monon freight train in this 1969 photograph was being pulled across the Wildcat Creek Bridge by No. 518, an Alco Century 420 medium sized switch engine. This was one of Alco's more successful diesels and some are still in use, especially with short-line railroads. Alco built the C-420 from 1956 through 1968, and it had an engine rated at 2,000 horsepower. This bridge had a speed limit of 25 miles per hour and was the longest bridge on the Monon line at 685 feet. (Photograph by Dave Ritenour.)

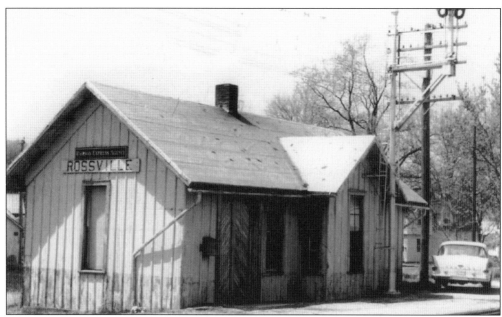

ROSSVILLE DEPOT. The Monon Railroad had a combination depot at Rossville that served the grain elevator and the poultry industry. The railroad line was completed in 1883 and ran from Indianapolis to Chicago on the trackage that had belonged to the Chicago and Indianapolis Air Line. The automobile in the photograph dates the depot to the late 1950s or early 1960s. (Photograph by Bill Stewart, courtesy of John Fuller.)

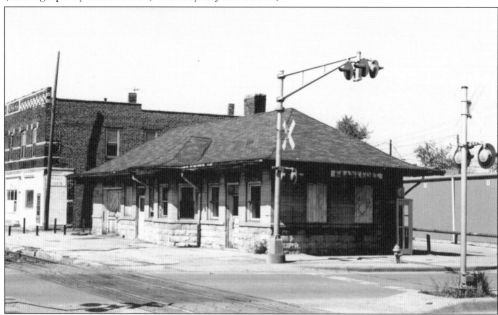

FRANKFORT DEPOT. Between 1899 and 1909, Monon Railroad president W. H. McDoel, commissioned a series of six Indiana limestone depots including this one at Frankfort. This depot was built in 1901 at a cost of $7,747. One of Frankfort's claims to fame is that in 1928, the Kemp Brothers Packing Company claims to have made the first tomato juice. The photograph was taken in 1981 and the depot was demolished around 1999. (Photograph by Jeff Strombeck.)

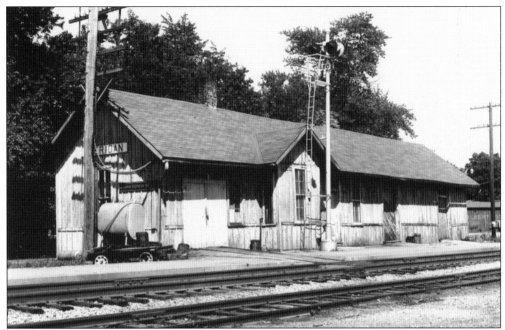

SHERIDAN DEPOT. This Monon combination frame depot has board-and-batten siding with a bay window. It has been relocated from Sheridan, in Hamilton County, to a new site in Hamilton County. It is one of only about 16 Monon depots remaining and is now being used for private storage. This photograph was taken in 1973. (Photograph by John Strombeck.)

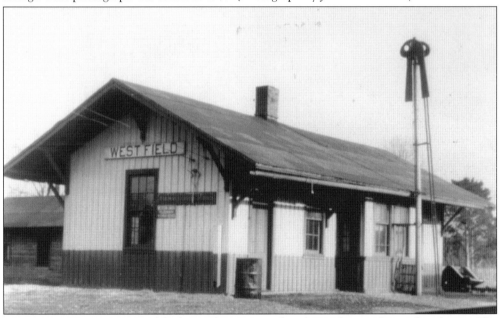

WEST FIELD DEPOT. West Field is located in an agricultural area that produces a lot of grain. The Monon Railroad worked the grain elevators in this farm area. This framed wooden depot had been demolished by 1977. In the 1850s, West Field was a stop along the Underground Railroad. This is not surprising because Quakers, who were not supporters of slavery, settled West Field. (Photograph by Charles Huffer, courtesy of MRHTS.)

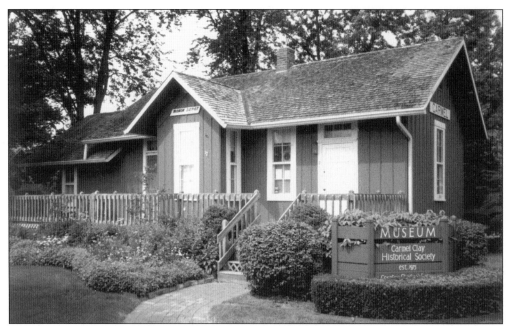

CARMEL DEPOT. The Monon depot at Carmel is now being used as a museum. In 1882, rails of the Monon were laid through Carmel, and a depot was opened there in 1883. The depot remained open until 1974 and was restored in 1989 by the Carmel-Clay Historical Society. The tracks have been removed and the rail bed is now used as a walking trail called the Monon Trail.

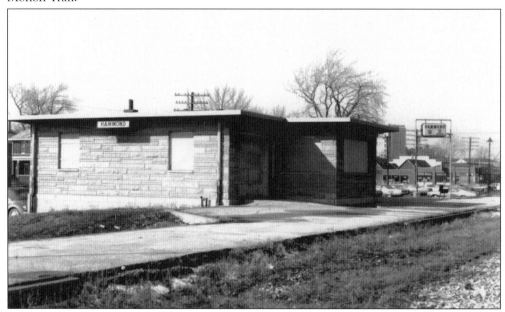

SOUTH HAMMOND DEPOT. The Monon's route from Chicago to Louisville covered areas from South Hammond down to Crawfordsville. Depots south of Crawfordsville were reviewed in *Railroad Depots of Southern Indiana*. The passenger depot at South Hammond was built in 1953. It was torn down in the 1980s. This was a joint station shared with the Erie Railroad. Near this location was the now abandoned and vacant South Hammond train yard. (Photograph by Dick Fontaine.)

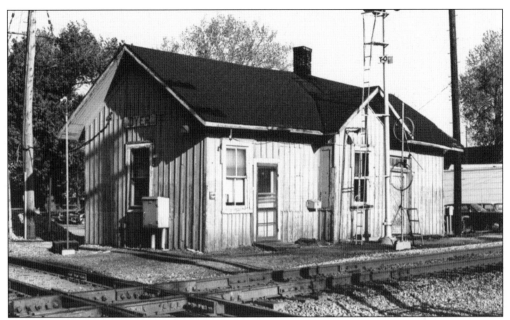

DYER DEPOT. The Dyer depot is no longer standing, but the town does still have a tie to railroading. Dyer has an Amtrak shelter at 913 Sheffield Avenue on the Cardinal and Hoosier State route. As one can see from the photograph, Dyer was a junction depot with the Elgin, Joliet and Eastern Railway. This photograph, taken in 1977, shows the Elgin, Joliet and Eastern Railway and Monon Railroad diamond. (Photograph by John Strombeck.)

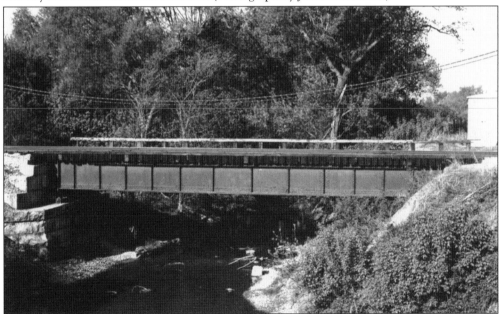

BRIDGE AT DYER. This small steel bridge was used by the Monon Railroad to cross this small stream at Dyer. Dyer was located at milepost No. 29, and had been a stop on the Chicago and Indianapolis Air Line before it was acquired by the Monon Railroad in 1883. Dyer was an important interchange as it connected with the very successful Elgin, Joliet and Eastern Railway. (Photograph by John Strombeck.)

CEDAR LAKE. The area was first called Paisley, but was later changed to Cedar Lake around 1899. Cedar Lake was originally called the Lake of the Red Cedars. It was a resort used by many patrons from the Chicago area. They came here for fishing, boating, swimming, and dancing, which helped keep this Monon Railroad busy from 1890 to 1929. This image shows the most recent Cedar Lake depot. (Photograph by Dick Fontaine.)

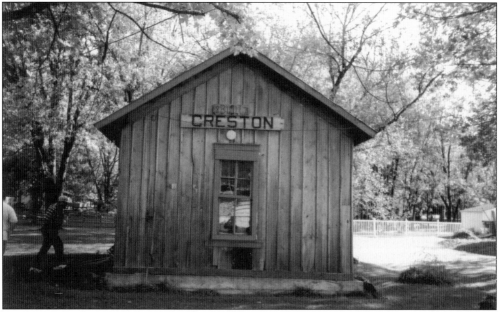

CRESTON DEPOT. This photograph shows the Creston combination depot as it exists today. It has been relocated to private property a few miles from Creston and is used for private storage. It is a frame construction depot that was built in 1882. Its existence was in doubt by some, but during the 2003 Monon Railroad Historical-Technical Society's annual convention, this depot was visited while members were tracing part of the Monon's old rail line.

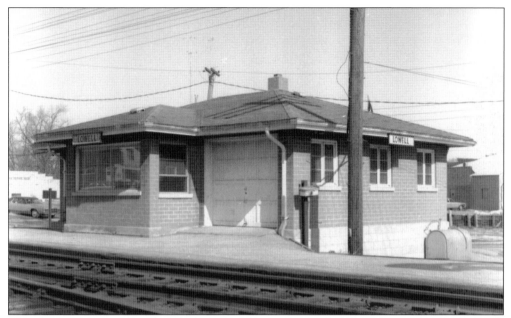

LOWELL MONON DEPOT. This combination depot is located on Commercial Street in Lowell. It is still in use by the CSX Railroad as an office. This brick building was constructed in 1953 and replaced a depot that was demolished by a derailment in May 1952. Train No. 71 derailed 30 cars, some of which contained petroleum products, causing an explosion. (Photograph by Dick Fontaine.)

SHELBY MONON DEPOT. The Shelby depot was a combination depot of frame construction built in 1904. The New York Central and the Monon Railroads shared this depot. The Monon's portion of the cost of construction was $4,052 with the Chicago, Indiana, and Southern Railroad, by an earlier agreement, paying a like sum. This photograph was taken in 1973, and the depot was torn down soon after. (Photograph by John Strombeck.)

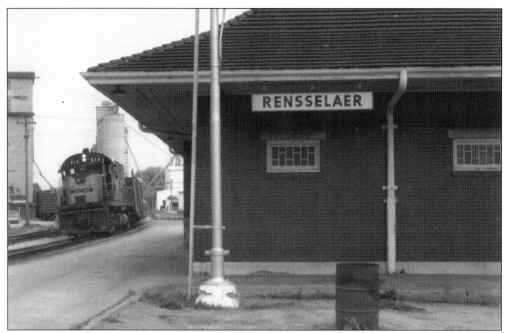

Diesel Approaching Rensselaer. This image shows a Monon C-420 diesel, No. 514, approaching the Rensselaer depot. These engines were purchased from Alco in 1966 and 1967. In the background, the grain elevator can be seen. An Amtrak wooden waiting shelter now stands where this depot stood at 619 North Cullen Street. (Photograph by Dave Ritenour.)

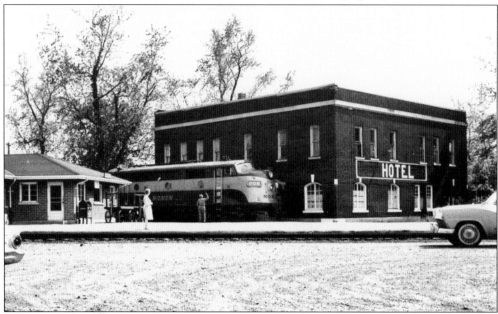

Monon Passenger Depot. This photograph shows the present depot at Monon. A runaway train took out the previous limestone depot at this site in 1951, and this brick depot was built two years later. This 1963 image shows the Monon Hotel on the west side of the track and an F-3 Monon diesel engine waiting at the depot. Today it is used as a CSX Railroad office. (Photograph by Esther Strombeck.)

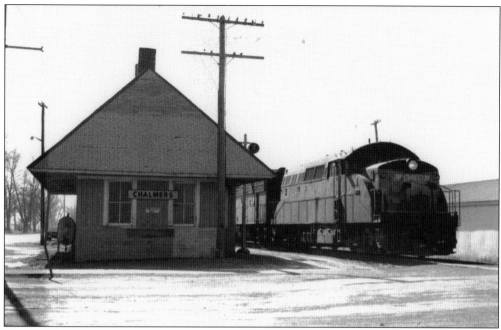

CHALMERS DEPOT. Chalmers was also called Mudge's Station after a local storekeeper. The depot was built in 1895 and was a frame building with shingle hip roof. The depot was located south of Main Street on the east side of the tracks. To the right of the depot is a BL-2 diesel locomotive. (Photograph by Dick Fontaine.)

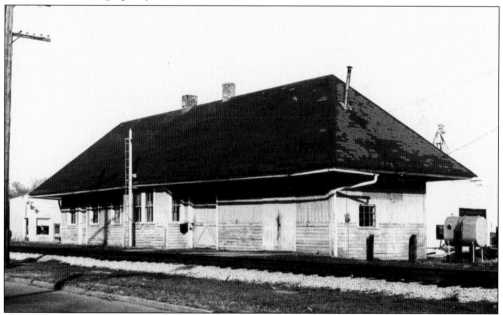

BROOKSTON DEPOT. Brookston was named after James Brooks of New Albany who was the first president of the New Albany and Salem Railroad. The New Albany and Salem Railroad, now called the Monon Railroad, began in 1847. The depot in this photograph was built in 1898. In 1971, the Monon merged with the Louisville and Nashville Railroad, ending its 124-year history. This photograph was taken in 1972. (Photograph by John Strombeck.)

LAFAYETTE MONON PASSENGER. The Lafayette Monon passenger depot is located at 322 Fifth Street. The exterior is made of smooth limestone and has an inscription of the Monon logo above the ticket office. Between 1899 and 1909, president W. H. McDoel commissioned a series of six limestone depots including this one at Lafayette. This depot was built in 1901. It now serves as a civic theater for the Lafayette community.

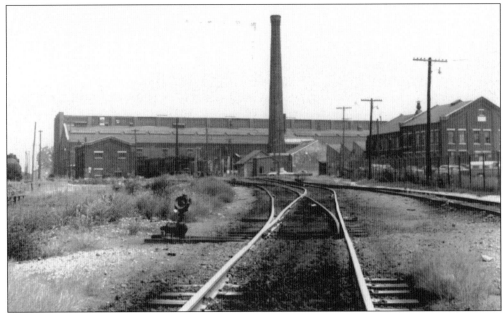

LAFAYETTE SHOPS. In the 1890s, the Monon Railroad began discussions about the need to move the shops from New Albany. In 1892, the citizens of Tippecanoe County's Fairfield Township voted to donate money and land to the Monon Railroad if they would move the shops complex to Lafayette. They were successful and the new Lafayette shops opened in 1895. This photograph shows some of the shops before demolition began in 1995. (Photograph by Dick Fontaine.)

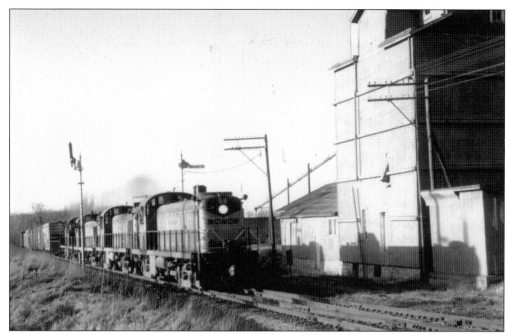

TAYLOR STATION. This photograph shows a southbound Monon train being pulled by four RS-2 diesels. The lead locomotive, No. 52, is shown passing the elevators at Taylor Station in May 1969. Taylor is located between Linden and Lafayette in Tippecanoe County. The engineer in this photograph is Ron Marquardt. (Photograph by Dave Ritenour.)

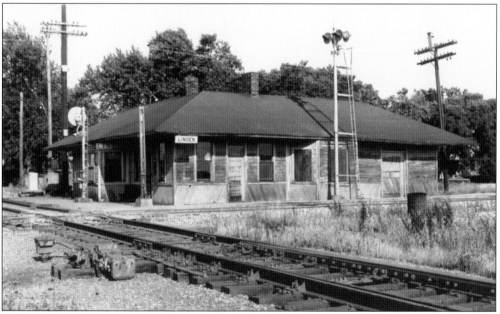

LINDEN DEPOT. This image shows the diamond of the juncture passenger depot at the town of Linden. The Monon and the Toledo, St. Louis, and Western Railroads used the depot that was built in 1905. It is located north of Crawfordsville on U.S. 231 and is an L-shaped building. The depot had been restored and now serves as a railroad museum. This photograph was taken in 1973. (Photograph by John Strombeck.)

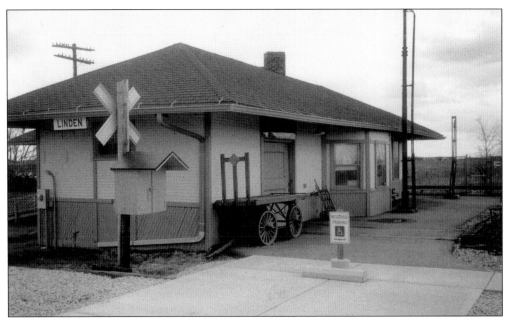

LINDEN DEPOT TODAY. The Linden depot today serves as the international headquarters of the Monon Railroad Historical-Technical Society. The Nickel Plate Road tracks have been removed and the north and south tracks are now used by the CSX Railroad. Several exhibits of restored Monon Railroad rolling stock are part of the museum's static display. The depot was placed on the National Register of Historic Places in 1991.

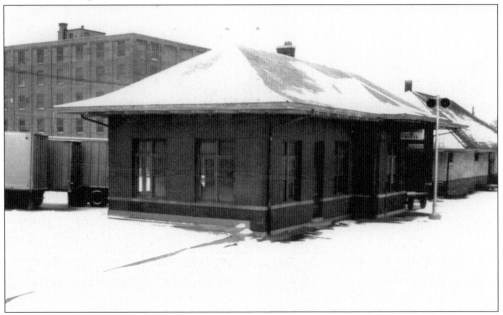

CRAWFORDSVILLE DEPOT. This Crawfordsville passenger depot was built is 1926. Today Amtrak uses the stop at Spring and Green Streets and has built a small enclosed metal shelter along the tracks. This photograph shows the remaining passenger depot (left) and the freight house, which has since been torn down. To the far left are Monon Railroad truck trailers. The station is now a restaurant. (Photograph by Dick Fontaine.)

Five

THE SOUTH SHORE LINE

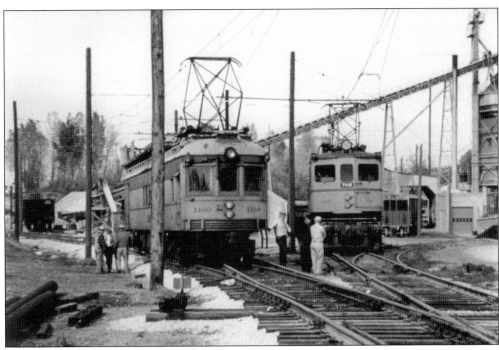

SOUTH SHORE LINE TROLLEYS. In 1901, the Chicago and Indiana Air Line Railway was incorporated. It was not until 1906 that construction on the line began and in 1925 the name was changed to the familiar, Chicago, South Shore and South Bend Railroad. It then became part of the large Samuel Insull Company. This photograph shows line car No. 1100 (left) and locomotive No. 705 and was taken at the South Bend Sand and Gravel Company in October 1961. (Photograph by Sanford A. Goodrick Jr.)

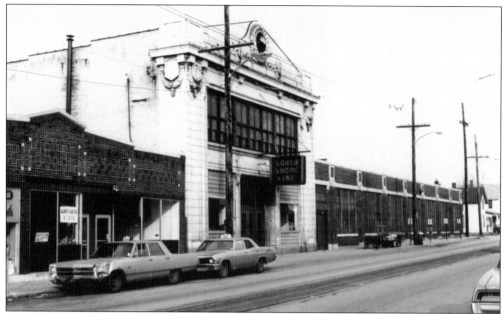

Michigan City Eleventh Street Station. In May 1927, this Michigan City South Shore Line station opened for the first time. It is located at 114 East Eleventh Street and has an exterior surface of terra cotta and brick. Today a small South Shore Line waiting shelter sits about where the wagon sits in this 1973 photograph. The station is no longer used and the brick building to the right has been removed. (Photograph by Jeff Strombeck.)

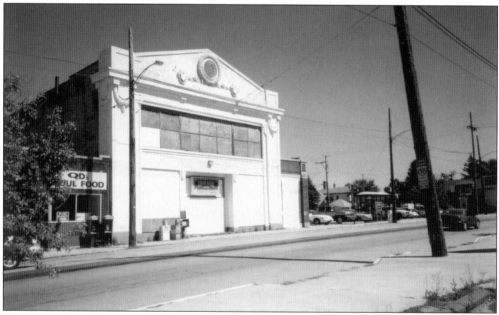

Michigan City Eleventh Street Shelter. Even today, the station is recognized as one that had special significance. It still retains its neoclassical front, even though it has been vacant for many years. In this photograph the South Shore Line shelter is to the right. Today the interurban line is called the Northern Indiana Commuter Transportation District. These trains still "street run" in cities like Michigan City, where city traffic must move cautiously around rail traffic.

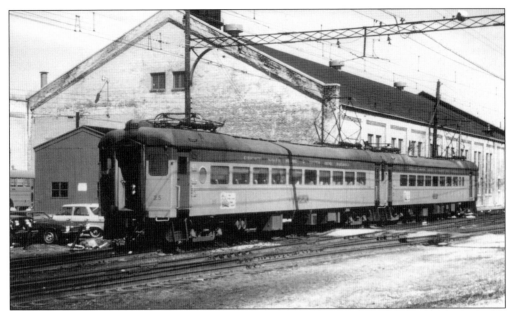

TROLLEY AT MICHIGAN CITY. This 1975 photograph shows a Chicago, South Shore and South Bend Railroad trolley in Michigan City. The large building in the background is part of the Chicago, South Shore and South Bend Railroad shops and yard. When trolley service first began in 1908, trains between South Bend and Michigan City ran every two hours and it only cost 65¢ for a one-way ticket. (Photograph by John Strombeck.)

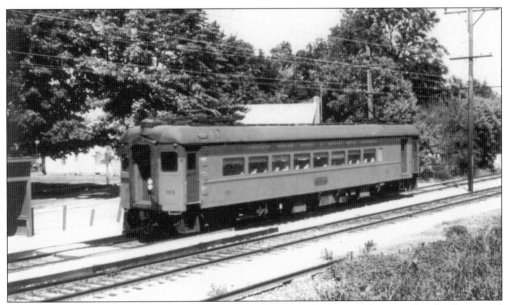

TROLLEY AT NEW CARLISLE. This June 1972 photograph shows Chicago, South Shore and South Bend Railroad trolley No. 105 at New Carlisle. New Carlisle is located between South Bend and Michigan City and was a Chicago, South Shore and South Bend Railroad flag stop until 1992. At a flag stop, passengers must signal to the engineer by activating a special light in order for the train to stop. New Carlisle was once the site of a power substation of the Chicago, South Shore and South Bend Railroad. (Courtesy of Jeff Strombeck.)

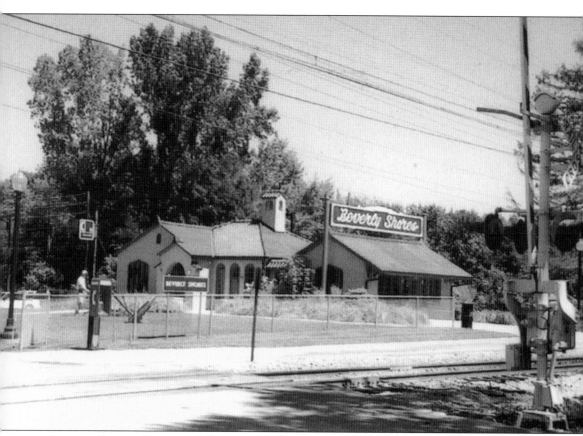

BEVERLY SHORES STATION. When one first looks at a photograph of this station, one wonders why there seems to be such an inequity among the South Shore Line stops. Some are just simplistic shelters with three sides. Yet there are stations like Beverly Shores that have such style and design. This station is noted for its Spanish Colonial Revival style of architecture. It was built in 1929, under the leadership of Samuel Insull, as a passenger stop for South Shore Line commuters. Its construction was an upgrade from other Chicago, South Shore and South Bend Railroad constructions. One of the more notable features of this depot would be the neon sign on the roof. This station, like most, fell into years of disrepair as the interurban was greatly affected by the onslaught of the automobile. Today this historic station is still in use and has a small museum. The Beverly Shores Chicago, South Shore Station has been recently restored and is located at Broadway Street and U.S. Highway 12.

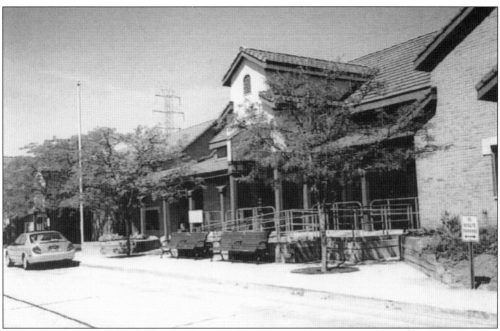

DUNE PARK STATION. The passenger station at Dune Park is quite impressive. It is one of the major commuter stations on the South Shore Line. It is the home office for Northern Indiana Commuter Transportation District and includes a visitor's center for the Dunes National Lakeshore. It is located at U.S. Highway 12 and State Road 49 and was built in 1985.

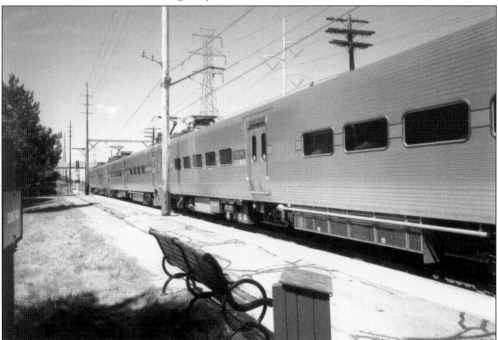

SOUTH SHORE LINE TRAIN. This trackside photograph was taken in 2004 at Dune Park Station and shows the type of train cars being used currently by the South Shore Line with the electric power lines above the rail line. This photograph was taken looking west, toward Chicago.

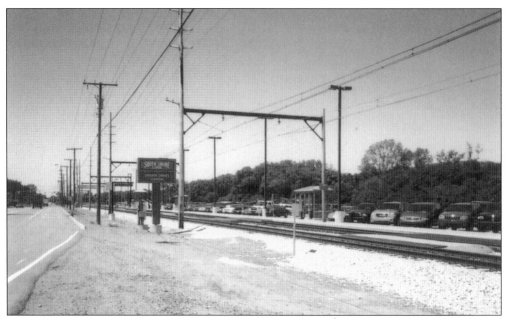

OGDEN DUNES. The Ogden Dunes stop was always a vital link in the Chicago, South Shore and South Bend Railroad line. It was one of the first eight substations built in 1925. In 1995, plans were made by the Northern Indiana Commuter Transportation District for improvements at Miller, Dune Park, Ogden Dunes, and East Chicago stations. This photograph shows the improvements at the Ogden Dunes station, which is located on Hillcrest Road at U.S. Highway 12.

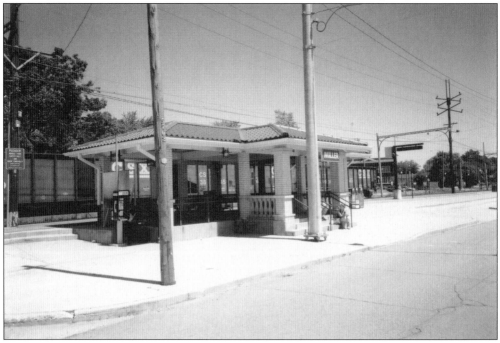

MILLER SOUTH SHORE. The Miller waiting shelter is located on U.S. Highway 12 near Lake Street, just a few miles east of Gary. It has an open front and was built in 1998. There is a huge parking area west of the shelter. This photograph was taken in 2004.

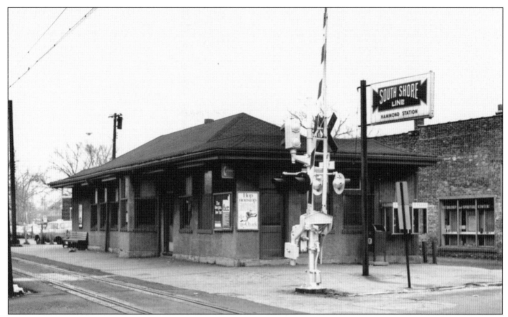

HAMMOND STATION. This station has been torn down, but was used for many years by the South Shore Line as the stop in Hammond. This photograph was taken in 1976. Notice the various signs on and around the station. Railroad stations and depots were great places for companies to advertise their products as this gave waiting commuters something to read. (Photograph by John Strombeck.)

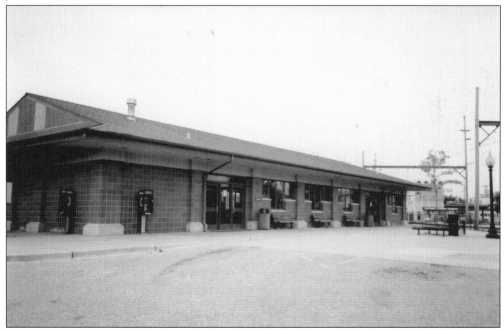

NEW HAMMOND STATION. In 1977, the Northern Indiana Commuter Transportation District was established by the Indiana General Assembly. This allowed it to receive federal government money to purchase new passenger cars and to begin managing and marketing the interurban service. This brick waiting shelter is at 4531 Hohman Avenue. It was built in 1998.

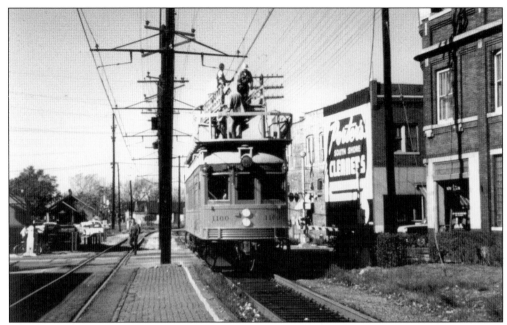

HAMMOND TROLLEY. This photograph was taken in October 1962 and shows South Shore Line train No. 1100 being repaired. There appears to be a malfunction with the electric connections, as workers are on top of the car. Much newer electric cars have been acquired in recent years to accommodate ridership, need, and growth. (Photograph by Sanford A. Goodrick Jr.)

EAST CHICAGO STATION. In 1982, new passenger trains entered service for the Northern Indiana Commuter Transportation District. In 1989, it had three and a half million passengers. This South Shore Line station is larger and is more elaborate than some. It is located at 5615 Indianapolis Boulevard and was built in 2004.

Six

THE AMTRAK IN INDIANA

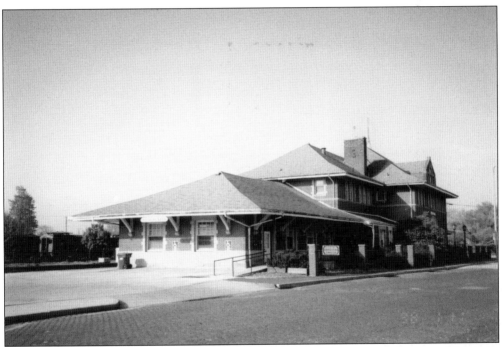

ELKHART PASSENGER DEPOT. In May 1971, passenger railroad transportation moved from the private sector to Amtrak, a system under the control of the United States Congress. Amtrak was dedicated to providing efficient and attractive passenger rail service for the American traveler. One of the Amtrak routes still crossing Indiana is the Lakeshore Limited. South Bend is the first eastbound stop and Elkhart is the second. Most Amtrak stops are not as elaborate as this Elkhart station, but Amtrak uses this old Lake Shore and Michigan Southern Railroad passenger depot at 131 Tyler Avenue, which is off Main Street, for their regional offices.

WATERLOO WAITING SHELTER. Waterloo is the third stop in Indiana on the Lakeshore Limited as it moves eastward toward New York. Waterloo is located in the northeast corner of Indiana. This Waterloo shelter is located at Lincoln and Center Streets near the combination depot mentioned in chapter 1. Such a shelter is designed to help keep commuters out of the harsh northern Indiana weather.

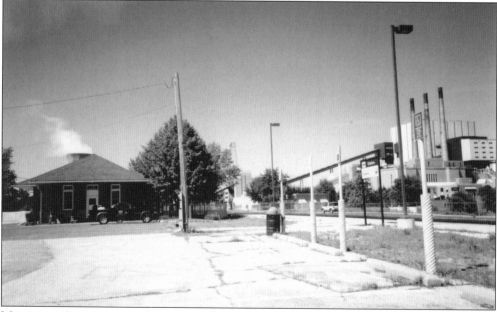

MICHIGAN CITY SHELTER. Michigan City is a stop of the Wolverine and Blue Water Service route, which goes from Chicago to Pontiac, Michigan. The Amtrak shelter, a simple steel structure, is located at 100 Washington Street. It takes travelers about 75 minutes to go from Chicago's Union Station to Michigan City. On this route, passengers may be provided with beverages and snacks as part of the business class service.

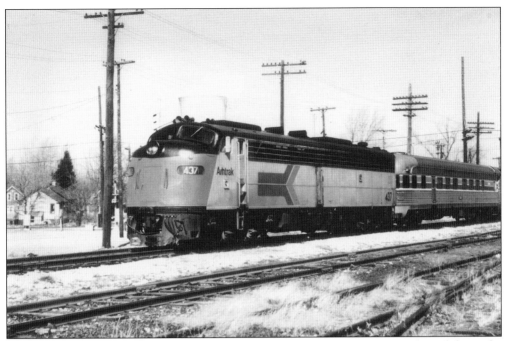

AMTRAK TRAIN NO. 437. This photograph was taken in 1976 in Michigan City and shows the paint scheme then used on Amtrak trains. Amtrak has usually used a silver, red, white, and blue paint scheme, to signify the nation's colors. (Photograph by John Strombeck.)

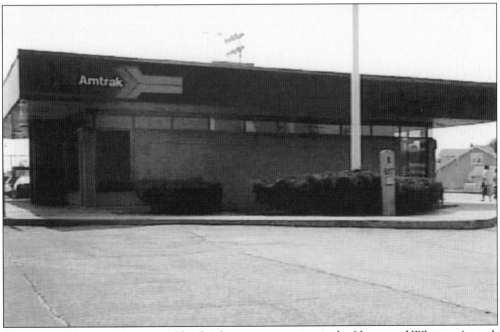

HAMMOND-WHITING STATION. This brick passenger station is the Hammond-Whiting Amtrak station. It is the second of two Indiana stops on the Wolverine and Blue Water Service line from Chicago to Pontiac, Michigan. This station was built in 1982 and is located at 1135 South Calumet Avenue. It was designed by Isan Akin of Philadelphia.

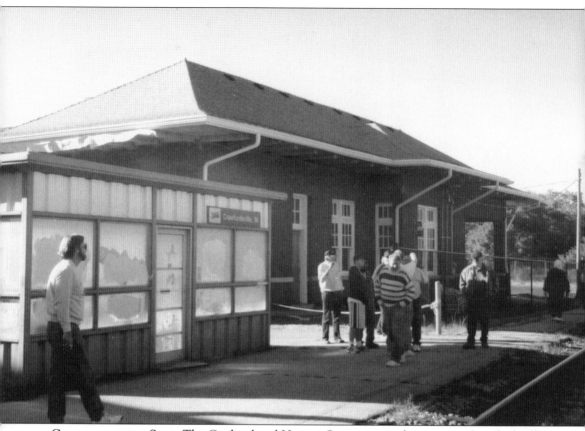

CRAWFORDSVILLE STOP. The Cardinal and Hoosier State route makes stops at Crawfordsville, Lafayette, Rensselaer, and Dyer, all of which were stops on the old Monon line. The first Amtrak stop west and north of Indianapolis is the Crawfordsville stop at the old Monon passenger depot on West Green Street. The brick depot can be seen in this photograph behind the shelter. The Amtrak shelter is constructed of metal and glass and has a flat roof. The brick depot has recently been converted into a restaurant. Amtrak today uses former Monon trackage from Crawfordsville through Dyer. The crowd in the photograph was not waiting for an Amtrak train on this day. They were part of a bus tour of Crawfordsville and other areas sponsored by Monon Railroad Historical-Technical Society. Chapter 4, page 100, shows an older photograph of this depot before Amtrak was begun.

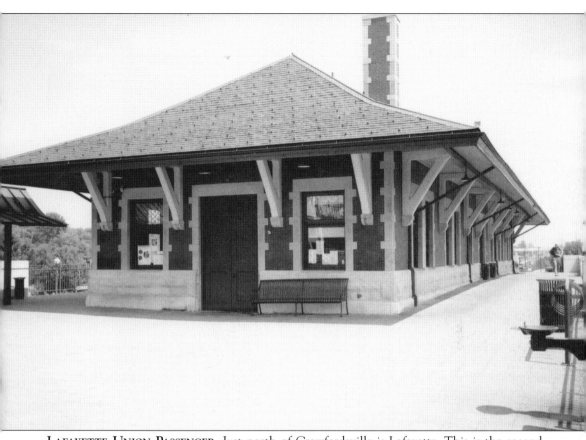

LAFAYETTE UNION PASSENGER. Just north of Crawfordsville is Lafayette. This is the second stop of the four on the Cardinal and Hoosier State route. This brick Lake Erie and Western Railroad and Cleveland, Cincinnati, Chicago and St. Louis Railroad passenger depot has been relocated from South and Second Streets to the corner of Wabash Avenue at Main Street. It was built in 1902 and is of the same design as the Lake Erie and Western Railroad depot in Tipton. The nearby tracks are in use by CSX Railroad and Amtrak. The depot has been restored and was raised so that a basement area could be constructed beneath it for patron and office use. It is now located at 200 North Second Street, within the J. F. Riehle Plaza, which includes the depot and a bus station. The J. F. Riehle Plaza was named for a recent Lafayette mayor under whose administration this and other railroad related projects were completed.

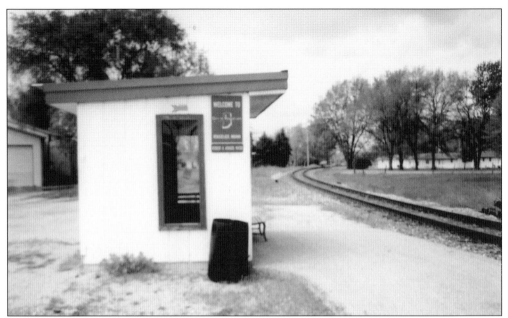

RENSSELAER SHELTER. The third Amtrak stop north of Indianapolis is at Rensselaer. This shelter was built in 1979 on the same site that once held the Rensselaer Monon depot. Those traveling on the route from Chicago to New York will find services such as sleeping cars and dining cars offering full meals. The fourth stop is at Dyer in Lake County, which also has a simple shelter.

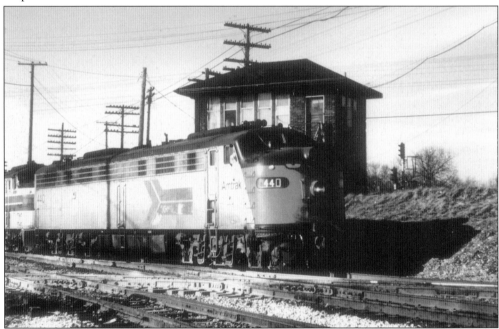

AMTRAK TRAIN AT GRIFFITH. This photograph was taken is 1976 and shows an Amtrak train at the Griffith Tower. This is not the tower that is currently on the property of the Griffith depot, which is the Griffith Historical Park and Railroad Museum. The current tower is an Elgin, Joliet, and Eastern Railway tower acquired by the Griffith Historical Society. (Photograph by John Strombeck.)

Seven

THE CENTRAL INDIANA AND WESTERN SHORT LINE

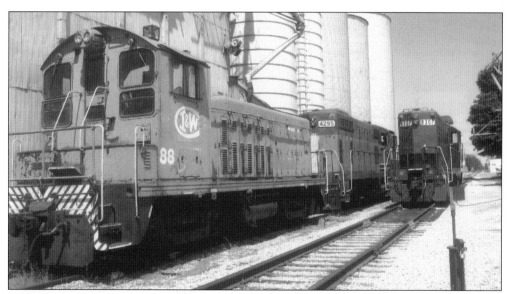

THE CENTRAL INDIANA AND WESTERN. The Central Indiana and Western Railroad had its origins as the Anderson, Lebanon and St. Louis Railroad when chartered around 1875. In 1976, when the short-lived Penn Central Railroad went bankrupt, it became part of Conrail. The railroad was purchased from Conrail in 1986. Mark Brown is the current owner of the Central Indiana and Western Railroad. This photograph shows the three locomotives owned by the Central Indiana and Western Railroad.

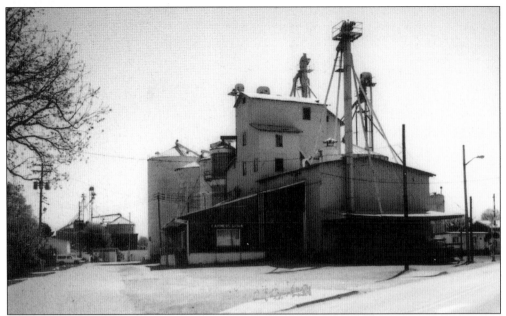

THE GRAIN MILL. This photograph shows the Farmer's Grain Offices and the grain elevator on the west side of Lapel. The Central Indiana and Western Railroad is a switch carrier and provides rail service between Lapel and Anderson. The rail line interchanges with CSX Railroad in the South Anderson rail yard. Grain elevators located on the east side of Lapel can be seen to the left.

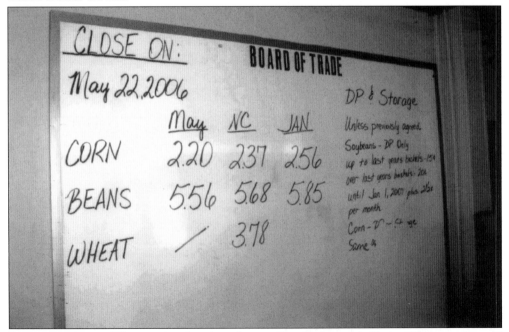

BOARD OF TRADE. This simple white board is used by the Farmer's Grain Offices at the mill to communicate the current grain prices to local farmers. The information on this board gives the closing grain prices from May 2006 for corn, soybeans, and wheat. It also gives the cost for storage of the grain until when it is sold.

TRUCK SCALE. This photograph shows the truck bay used when farmers bring their grain to the mill and the in-floor scales used to weigh the truck both when full of grain and again after the grain is removed. Near the ceiling is a pulley system used to empty the grain from the truck. At the far end of the bay is the pipe used to vacuum grain out of the trucks.

ONE MAN ELEVATOR. This wooden elevator is no longer used, but it allowed the workers to go up to a second floor in the grain elevator. A worker could stand on the platform and pull himself up to the next level using a rope and pulley system. Most of this system was made of wood, which explains the presence of the fire extinguisher.

GRAIN BAG SEWING MACHINE. Look beyond the dust and cobwebs and visualize the worker operating this sewing machine. This was an industrial strength machine that could sew up the ends of burlap grain bags filled in the mill. To the right is the spool of thread used for this operation.

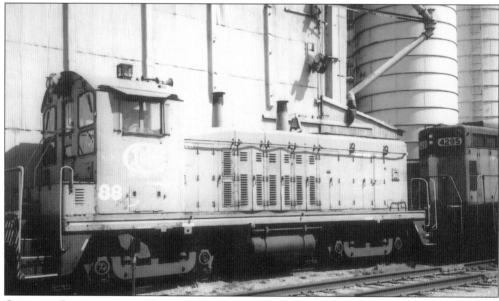

CENTRAL INDIANA AND WESTERN LOCOMOTIVE. In November 1986, the Central Indiana Railway became the Central Indiana and Western Railroad. This photograph shows Central Indiana and Western Railroad locomotive No. 88 alongside the grain elevator. This was an EMD SW7 diesel switch engine that was purchased in 1986 and was proven to be a very economical and reliable switcher. They were introduced in 1949 by the General Motors Electro-Motive Division.

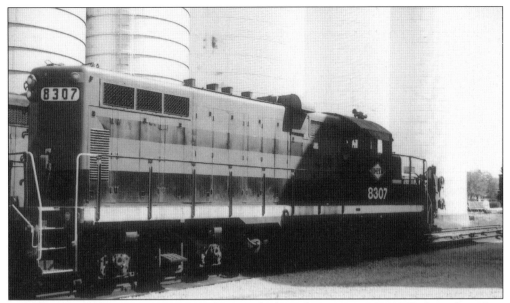

LOCOMOTIVE EMD NO. 8307. This photograph shows locomotive No. 8307 along the siding in Lapel. The Central Indiana and Western Railroad purchased this engine in 2002. Today the Central Indiana and Western Railroad hauls grain, silica, sand, and soda ash for the Owens-Illinois plant. This switcher locomotive is an Electro-Motive Division GP-8 that had belonged to the Paducah and Louisville Railroad. The GP stands for "general purpose," referring to the many uses of the locomotive.

BRUSH CUTTER. This on-track brush cutter is used to keep the track cleared of weeds and other brush. This adds to the safety of the railroad by keeping the track free of weeds that would inhibit vision. Track maintenance is a very important aspect of operating a short line. When business is slow, there is always track maintenance work to be done. The line also has a John Deere backhoe for other rail maintenance work.

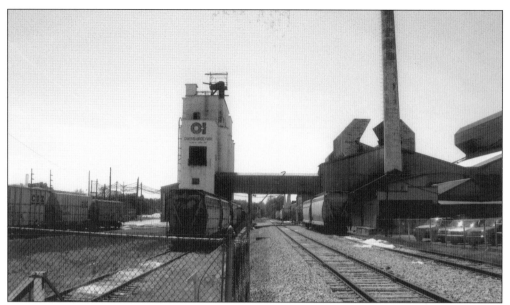

OWENS-ILLINOIS PLANT. The glass business in Lapel has a history going back to around 1900, according to John Hudson, plant superintendent. He said that the Central Indiana and Western Railroad is the lifeline of the Owens-Illinois plant. In 1903, Michael J. Owens invented the first completely automatic glass bottle–blowing machine making it possible to mass-produce glass bottles and jars. Nearly every glass container made worldwide is manufactured by Owens-Illinois.

SPUR LINE. The shipping of grain from the Lapel area makes up only 1 percent of the business of the Central Indiana and Western Railroad short line. The other 99 percent lies at the end of this short spur line. This photograph shows the spur line that brings resources to the Owens-Illinois factory entrance. On this spur line the rail delivers sand, lime, soda ash, aplite, and cullet, all used to manufacture glass containers.

Eight

PRESERVATION OF
OUR RAIL HERITAGE

INDIANA TRANSPORTATION MUSEUM. This Electro-Motive Diesel General Purpose road switcher is one of the locomotives that have been restored by the volunteers at the Indiana Transportation Museum. It is returning to Hobbs Depot for food and passengers before its 22-mile round-trip run to Atlanta, a nearby Hoosier town. To its left is one of the museum's stainless steel Budd coaches. The Budd Company manufactured these lightweight, streamlined passenger cars in the late 1940s.

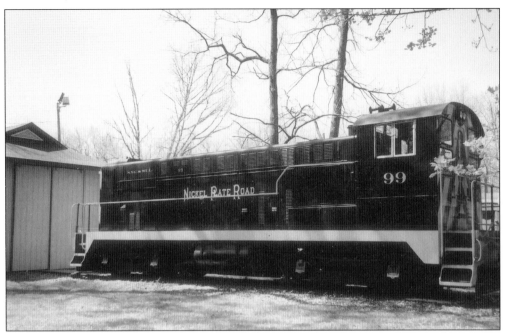

NICKEL PLATE NO. 99. The Indiana Transportation Museum has a Baldwin V-1000 diesel locomotive as part of its collection. This locomotive was never used by Nickel Plate Road, but it was used in southern Indiana at the Crane Naval Weapons Center. Crane Naval Weapons Center donated the engine to the museum.

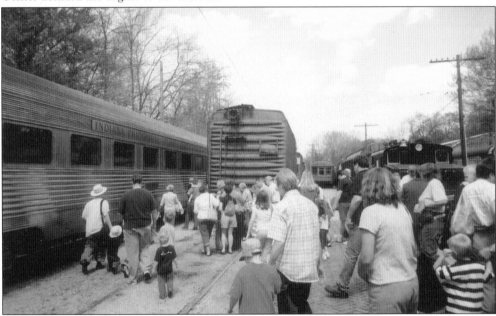

TIME OF DEPARTURE. Some of the goals of the Indiana Transportation Museum are to preserve Indiana's railroad history and to provide visitors an opportunity to experience traveling on a train. In this photograph the conductor has seen that the engineer is ready and that the food has been loaded. Now he calls for the passengers to board the Budd coach for an excursion called the Weekend Express.

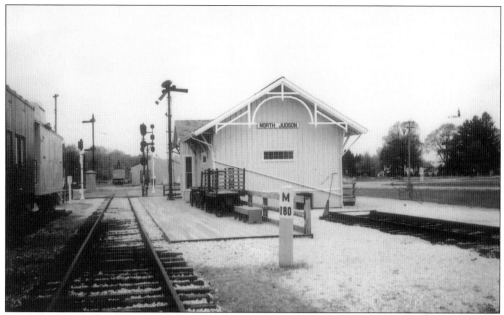

HOOSIER VALLEY RAILROAD MUSEUM. One will also find an excursion railroad at the Hoosier Valley Railroad Museum in North Judson. This photograph shows the depot that was built in 1999 by museum members who used Chesapeake and Ohio Railroad depot building plans. It also shows a small portion of their property, which includes over 30 pieces of rolling stock. North Judson was once a very active railroad town.

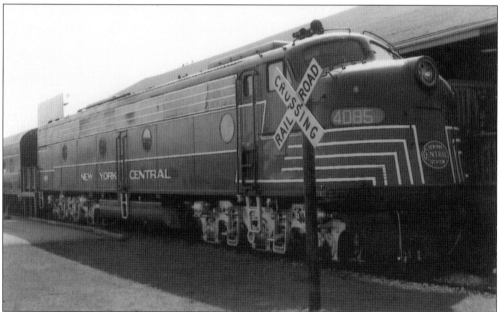

NEW YORK CENTRAL NO. 4085. The Elkhart freight house, discussed in chapter 2 on page 44, is the home of the National New York Central Museum. The museum attempts to recapture the days when railroads and depots were symbols of a community's success. This photograph shows an E-8 diesel-electric locomotive that was built in 1953. It was used as the lead locomotive on the east bound 20th Century Limited during its last Chicago to New York City run in 1967.

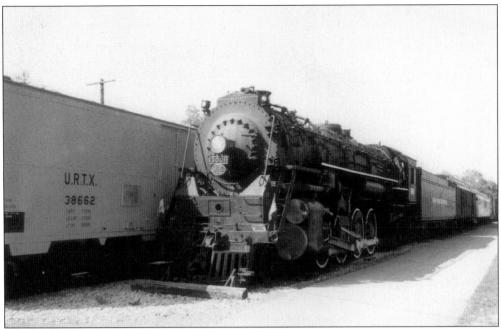

Steam Locomotive No. 3001. Also at the National New York Central Museum is this steam locomotive and coal tender. It is an L-3A Mohawk engine with a 4-8-2 wheel configuration. This means that the engine has four wheels in front, eight driving wheels, and two wheels under the cab. It was built in 1940, at a time when the diesel engine was just becoming popular.

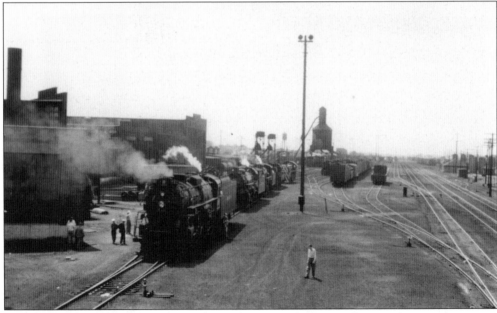

Frankfort Nickel Plate Yard. This vintage photograph shows the Nickel Plate Road train yard as it looked in August 1951. Steam can be seen rolling from several locomotives as they are lined up and ready for the day's assignments. The yard appears unending in length and full with the coaling tower, water tanks, several rail structures, rolling stock, and multiple tracks. (Photograph by Sandford A. Goodrick Jr.)

FRANKFORT NICKEL PLATE ROUNDHOUSE. Since 2004, the Historic Landmarks Foundation of Indiana has listed the Frankfort roundhouse as one of Indiana's 10 most endangered landmarks. This property is currently owned by Norfolk Southern Railway; however, the Frankfort Chamber of Commerce is currently talking with the railroad in an attempt to restore the prized old structure. Shown here is the interior of the old roundhouse, built in 1924.

FRANKFORT TURNTABLE. Early steam locomotives normally traveled only forward, but with later locomotives, the controls were more efficient and they could move in reverse. In this photograph, weeds have nearly hidden the turntable from view. In the center is the turntable bridge. This allowed for the engine to cross and move to the stalls for needed maintenance work.

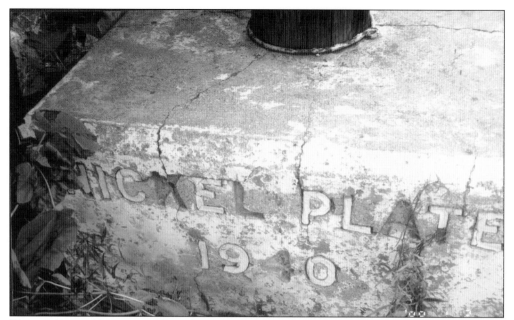

NICKEL PLATE FLAGPOLE. This photograph shows the base of the flagpole that still stands near the roundhouse building in Frankfort. On the base is evidence of when the flagpole and foundation was set. It reads, "Nickel Plate, 1940." However, several of the structures in the Nickel Plate yard had varying dates of construction. Norfolk Southern Railway owns the property, which is located between Morrison and Walnut Streets.

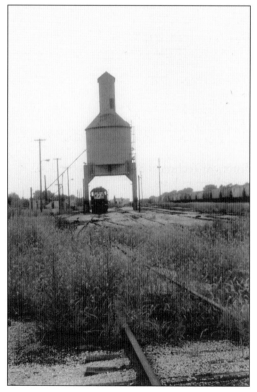

DIESEL UNDER THE COALING TOWER. This coaling tower was built in 1937, and by 1960, the Nickel Plate had retired all of its steam engines. The Norfolk Southern Railway diesel, under the coaling tower in Frankfort, makes for a great contrast of the old and the new. The city has hopes of transforming some of the old structures into a museum and reception hall. The busy Norfolk Southern Railway train yard is to the right of the tower.

BIBLIOGRAPHY

http://casscountyin.tripod.com/earlycass.htm
http://hometown.aol.com/chirailfan/ztransin.html
http://madisonrails.railfan.net/home.html
http://southshore.railfan.net/ss-hist.html
Indiana Historical Society. "All Aboard." *Traces*. Summer 2001: 32.
Kingsbury, Joe. "San Pierre." *Hoosier Line*. May 2006: 17.
Lewnard, Ed. "Locomotive Shops Demolished." *Hoosier Line*. May 1996.
Long, Steve. "Sentries of the Dark." *Hoosier Line*. March 1998.
"A Look Back." *Michigan City News Dispatch*. Michigan City, IN: July 13, 1973.
Parker, Francis H. *Depots of Indiana: A Threatened Heritage*. Muncie, IN: Ball State University, 1989.
Parker, Francis, and Richard Simons. *Railroads of Indiana*. Bloomington, IN: Indiana University Press, 1997.
"Time for Celebration on the Monon." *Hoosier Line*. August 1997.
Welsh, Joe. *The American Railroad*. Osceola, WI: MBI Publishing Co., 1999.
Wheeler, Robert. "Monon Tour Book." Monon Railroad Historical-Technical Society, October 2001.
———. "Monon Tour Book." Monon Railroad Historical-Technical Society, October 2003.
www.answers.com/topic/lake-shore-and-michigan-southern-railway
www.bremenhistoricalsociety.org/
www.davesrailpix.com/odds/in/htm/kmw01a.htm
www.fwarailfan.net/fortwayne_stat.htm
www.itm.org/index.htm
www.monon.monon.org/bygone/stateline.html
www.nkphts.org/history.html
www.nycrrmuseum.org/tour.htm
www.o-i.com/about/corporate/overview.asp
www.rootsweb.com/~inmarsha/2/railroad2.htm
www.sirus.com/users/tlout/
www.trainweb.org/rshs/great_railroad_stations.htm

Across America, People are Discovering Something Wonderful. Their Heritage.

Arcadia Publishing is the leading local history publisher in the United States. With more than 3,000 titles in print and hundreds of new titles released every year, Arcadia has extensive specialized experience chronicling the history of communities and celebrating America's hidden stories, bringing to life the people, places, and events from the past. To discover the history of other communities across the nation, please visit:

www.arcadiapublishing.com

Customized search tools allow you to find regional history books about the town where you grew up, the cities where your friends and family live, the town where your parents met, or even that retirement spot you've been dreaming about.